REMEMBERING

Lancaster County

STORIES FROM PENNSYLVANIA DUTCH COUNTRY

JACK BRUBAKER

THE
History
PRESS

Published by The History Press
Charleston, SC 29403
www.historypress.net

Front cover: Watercolor scene of a country auction painted by Lancaster County artist Hattie Brunner. *Courtesy Landis Valley Museum.*

Back cover: "The Garden Spot of the World: Lancaster County," a contemporary patchwork quilt, depicts the area's diverse heritage. *Copyright Donna Albert, 1999.*

First published 2010
Second printing 2010

Manufactured in the United States

ISBN 978.1.59629.863.7

Library of Congress Cataloging-in-Publication Data
Brubaker, John H.
Remembering Lancaster County : stories from Pennsylvania Dutch country / Jack
Brubaker.
p. cm.
ISBN 978-1-59629-863-7
1. Lancaster County (Pa.)--History, Local. 2. Lancaster County (Pa.)--Biography. I. Title.
F157.L2B778 2010
974.8'15--dc22
2010009386

To the memory of my grandparents
J. Harold and Helen Morgart Brubaker
Jacob F. and Blanche Christ Aierstock

CONTENTS

CONTENTS

CONTENTS

PREFACE

Mennonites first settled in what is today Lancaster County, Pennsylvania—sixty miles west of Philadelphia and just east of the Susquehanna River—in 1710. The Amish moved to the area nearly three decades later. Lancaster is often characterized as the first American home of the "Plain" religious sects. But early Lancaster, which became Pennsylvania's fourth county in 1729, also welcomed many other ethnic and religious groups in the early eighteenth century. Germans, English, Scots-Irish, French Huguenots, Quakers, Lutherans, Methodists, Episcopalians and others made the county one of the great melting pots of early America.

Blessed with some of the richest soil in the world, Lancaster County quickly became and remains one of the country's most productive farming regions. During the French and Indian War, and again during the Revolution, Lancaster was a military breadbasket.

Lancaster City, first settled in 1730, was the largest inland community in late colonial America and, for a time in the early nineteenth century, capital of Pennsylvania. It has produced its fair share of notable Americans, including Pennsylvania's only president.

Lancaster City and County have been subjects of several comprehensive histories, most notably: Franklin Ellis and Samuel Evans's monumental *History of Lancaster County, Pennsylvania* (1883); H.M.J. Klein's four-volume *Lancaster County Pennsylvania: A History* (1924); and John W.W. Loose's *The Heritage of Lancaster* (1978).

This book is not a history of Lancaster but a patchwork of stories representative of the rich heritage of this exceptional place. These stories originally appeared as columns in a feature called "The Scribbler" in the *Lancaster New Era*. One of the older columns in American newspapers, "The Scribbler" started its run in 1919 and has been published, with three interruptions, for the better part of a century. Since the late Gerald S. Lestz began writing the column twice a week in 1957, "The Scribbler" has focused largely on the county's history and culture. Lestz did much to foster popular appreciation for Lancaster's heritage before yielding the column to me in 1979.

In 2009, The History Press suggested assembling some of my columns into a book, and you hold the result in your hands. Longtime "Scribbler" readers will recognize that the book is not entirely representative of the column. For example, Dr. Scribblerchef's question-and-answer pieces do not appear here; nor do the early antics of the Little and Littler Scribbler. But the book does provide a fair sampling of the historical columns published over the past three decades.

The text, updated and adapted for this book, begins with stories of the Susquehanna River and Lancaster City—the county's most significant natural and human-made features—and ends with commentary on local preservation issues. In between, columns discuss the area's transportation and commerce, wartime Lancaster, influential citizens and memorable characters and the religious and ethnic groups that are most closely associated with this area—the Amish and the Pennsylvania Dutch.

The columns and the writing of them would not have been nearly so interesting without the contributions, over many years, of local historians John Loose and James McMullin. They also made suggestions and corrections that improved this book. Hundreds of other Lancastrians have contributed ideas without which the column would have been impoverished. Numerous historical books and articles, often cited in the text, provided further information.

I acknowledge the editors of the *New Era* over the past three decades—Ernest Schreiber, Robert Kozak and the late Daniel Cherry—for their supportive interest in local history and culture. Hannah Cassilly and the staff at The History Press have helped make republication of these columns an enjoyable process. I thank my parents, Marie and the late John H. Brubaker Jr.; my wife, Christine Brubaker; and my children, Lee Brubaker Hicks and Roger Brubaker, for their encouragement and support. They often determined what

would appear in these columns—either by suggesting subjects or by acting as sounding boards for columns to be.

I hope that this patchwork history will encourage readers to examine the county's story in greater detail and learn more about one of the most unusual places in America.

THE SUSQUEHANNA RIVER

INDIAN ROCK CARVINGS DRAW NEW INTEREST

In the Susquehanna River, directly below Safe Harbor Dam, carvings older than any other human creation exposed to the elements in Lancaster County decorate large rocks. Paul Nevin wants to preserve these carvings. "People should understand that there is a culture, a heritage throughout the area that goes back ten thousand years," said Nevin. "But people don't realize it because nothing is marked. I think there should be an interpretive display."

A self-employed carpenter and amateur archaeologist, Nevin lives in a converted sawmill on an unnamed Susquehanna tributary upriver at Accomac, York County. He began examining the carvings, called petroglyphs, in the mid-1980s. In the early '90s, he founded the Susquehanna Kalpulli to preserve Native American culture and the petroglyphs. The Kalpulli and the regional chapter of the Society for Pennsylvania Archaeology then formed the Friends of the Safe Harbor Petroglyphs. Although Big and Little Indian Rocks have been on the National Register of Historic Places since 1978, relatively few Lancaster or York County residents know much about them. Even fewer know about additional petroglyphs on nearby rocks.

In the summers of 1931 and 1932, just before Safe Harbor Dam backed up the waters of the Susquehanna River to form Lake Clarke, Pennsylvania Historical Commission archaeologist Donald Cadzow carefully studied petroglyphs that would be submerged on Walnut Island and Creswell Rock.

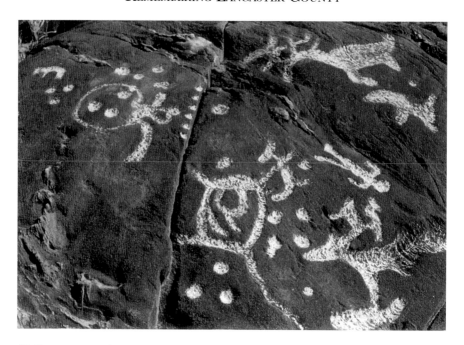

Chalk accentuates these petroglyphs carved into Circle Rock in the Susquehanna River. *Courtesy Paul Nevin.*

He also briefly examined Big and Little Indian Rocks, which would remain above water, before moving on to archaeological sites on the mainland.

Nevin took up where Cadzow stopped. On warm summer days, he paddled out to the rocks. He compared what he saw with what Cadzow had recorded. Then he began looking at other rocks. He found dozens of petroglyphs on four rocks that Cadzow had not mentioned in his report. These carvings include representations of animals, human beings and more abstract figures.

Through observation over several years, Nevin developed a much larger view of the Safe Harbor petroglyphs than Cadzow had imagined. He presented his ideas at a symposium on "rock art" at the State Museum in 1991 and has refined his thinking since then. Big and Little Indian Rocks and the four others (Nevin calls them Turkey Track, Eagle, Circle and Conestoga) stretch out into the Susquehanna in an almost perfect line from the Conestoga River's mouth. Nevin believes that is no coincidence. In addition to a Shenk's Ferry Indian settlement at Safe Harbor, a major Shenk's Ferry site has been excavated along the Conestoga at Millersville. Nevin thinks those Indians may have carved the rocks to emphasize the

Conestoga's significance to them. (Shenk's Ferry Indians preceded the Susquehannocks in this area.)

"Each rock has its own character," Nevin said. "They have certain figures in common, and there are some unique figures, too. It's incredible to me that they haven't been studied and there's not some sort of interpretive center that really recognizes this site for what it is. There aren't any more extensive sites than this in the Northeast."

Interpreting the rocks is one goal. Protecting them from further damage is another. While petroglyphs elsewhere in the country are protected in state and national parks, the Safe Harbor carvings are exposed to anyone with a hammer and chisel and a boat to float to the rocks. They also are open to gradual erosion by acid rain and scarring from ice floes. If they are not protected, Nevin fears, they may follow rock carvings submerged into oblivion by Lake Clarke.

Many academic archaeologists have ignored petroglyphs because the carvings' age and meaning cannot be determined. But that thinking is changing. Archaeologists with the Eastern State Rock Art Association, formed in 1996, are devoted to ending petroglyph neglect. "It's just been in the last few years," Nevin said, "that some archaeologists are willing to stick their necks out and say, well, maybe there's something more to the petroglyphs."

Nevin knows there is something more when he stands on Footprint Rock. Cadzow did not record the two footprints on the rock. Nevin spotted them when the water was low and registered them with the state as part of Little Indian Rock. The footprints are of bare feet, with toes splayed, the way toes operate when they have never been confined by shoes. Nevin has stood several times in the footprints on that rock, which aligns with all of the other carved Susquehanna rocks stretching out from the Conestoga River.

"Those footprints fit your feet just like a pair of shoes. You can stand right in them," he said. "When you stand in those footprints, you look directly at the mouth of the Conestoga."

EXAMINING THE RIVER'S POTHOLED ROCKS

In late summer, flows on the Susquehanna ordinarily bottom out. Low water exposes rocks. Exposed rocks exhibit potholes. In drought, many of the river's potholes, particularly in the area of Conewago Falls near Falmouth, are well above water. Some are as small as buckets; others are deep and wide

enough to hide a bear. They are filled with drought-dried fungi, small stones and mystery.

One might think that everything about potholes would be understood after years of geologic study, but "it depends how you look at it" could be the geologist's motto. In the last several years, rock experts have looked more closely and developed new theories.

Henry David Thoreau provided the common explanation of pothole formation in the nineteenth century:

> *A stone which the current has washed down, meeting with obstacles, revolves as on a pivot where it lies, gradually sinking in the course of centuries deeper and deeper into the rock, and in new freshets receiving the aid of fresh stones which are drawn into this trap and doomed to revolve there for an indefinite period, doing Sisyphys-like penance for stony sins, until they either wear out, or else are released by some revolution of nature.*

Many contemporary geologists would agree with that explanation. Bill Sevon, with the Pennsylvania Geological Survey, and Glenn Thompson, a geologist at Elizabethtown College, have refined the idea. While they believe

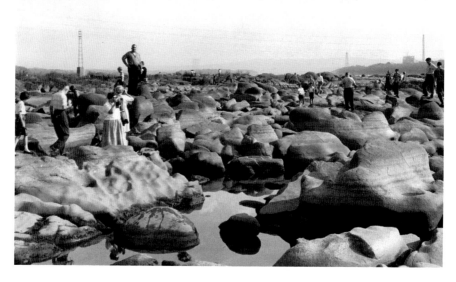

Severe drought and low water in 1963 drew visitors to rocks filled with potholes at Conewago Falls. *Lancaster Newspapers.*

that stones and small boulders performed the basic labor by swirling around and abrading the insides of potholes, Sevon and Thompson have wondered what force first breached the hard diabase rocks at Conewago Falls. They theorize that the potholes were formed by hydraulic vortices.

The best place to view vortices is in the tailraces of dams. What look like boils on the surface of the water are the tops of these vortices or, as Thompson calls them, "underwater tornadoes." These vortices found weaknesses in rocks. At first employing the smallest of gouging tools—a bit of sand or silt—they began to drill into fractured surfaces. Later vortices then drove larger material into created holes, rubbing their sides and spinning abraded material out into the river. All of this work has been accomplished over millions of years.

That's one theory.

E-an Zen, a University of Maryland scientist and expert on Potomac River geology, has different ideas about how potholes were formed. He has spent considerable time looking at holes in the rocks of the Potomac, Susquehanna and other rivers. He has looked long enough to notice two types of potholes. The standard kind, as described by Thoreau, is a vertical pothole, drilled into rock from the top. The other kind is a lateral pothole eroded by sediment pushed by water against the sides of rocks. This is how Zen described those holes in a technical paper in 1994:

> *The newly recognized lateral potholes are located on the sides of rock prominences, have incomplete circumferences, and are commonly found in groups strung out on the outcrop in the downstream direction. They are not circular; many are alcovelike with overhanging roofs.*

Zen maintains that lateral potholes, which are numerous at Conewago Falls and below Holtwood Dam on the Susquehanna, are not merely vertical potholes that have been breached. Their shape is different from vertical potholes. If you try to calculate a full circle from an incomplete lateral pothole, it doesn't work out. Both vertical and lateral potholes, Zen theorizes, were formed by hydraulic vortices swirling sediment against rock. Larger gouging tools, he believes, were not involved.

All of these geologists have spent a lot of time examining potholes at various locations. (No matter how long one looks, there's always something new to see. Bill Sevon published an article describing enormous rocks [he calls them diabase "blocks"] at Conewago that have been rolled so that their potholes are no longer on top. The potholes eroded first, he said, and

the force that rolled the blocks must have been an enormous glacial flood created by the catastrophic collapse of an ice dam upstream.)

The potholes, reached by hiking the old canal towpath north from the Falmouth Fish Commission Access just off Route 441, have been described as "sensuous." Another writer called them "tortured." They also have been called "hunger rocks" because they are exposed during low water, and farmers generally produce poorer crops under drought conditions.

ICE IN AUGUST:
SURPRISE FOR EARLY COAL DREDGERS

David Rankins was dredging coal particles from the bottom of the Susquehanna River at Shenk's Ferry in the summer of 1926 when his machinery pulled up something very different from anthracite. The prongs of Rankins's dredge snagged four large sections of ice, averaging nearly five feet in length. Rankins was surprised, and readers of Lancaster's *Sunday News* must have been shocked, when they read about this recovery on August 15.

Rankins lived in Conestoga and worked for the Anthracite Products Corporation, one of numerous coal-dredging operations on the lower Susquehanna. Millions of tons of waste anthracite from mines in the coal region near Wilkes-Barre had floated downriver. These coal particles settled on the bottom, where dredges began drawing them out in the last years of the nineteenth century. But the arduous process did not catch on fast. Removing coal from the river remained relatively novel in 1926, one year after Holtwood Dam began dredging coal for use in its steam-generating plant. Holtwood stopped dredging after Tropical Storm Agnes rearranged the Susquehanna's sediment load in 1972.

Removing ice from the river was even more novel, especially during a heat wave. On the day Rankins discovered ice, the temperature hovered around one hundred degrees.

The theory about how the ice survived into August was this: strong river currents drove the ice beneath rock formations. River sand washed over the ice, forming a kind of crust several inches thick. The heat of summer could not penetrate that layer. Something similar happened with ice at the Cottage Garden along Lincoln Highway East in 1994. Excavated dirt covered some of that winter's considerable snow and ice. When workers removed this insulating soil that July, they uncovered two large chunks of ice.

David Rankins lived in a more fanciful age. H. Clifton Thorbahn, the *Sunday News* reporter who chronicled the ice discovery, wrote with a more fanciful pen. Beyond scientific evidence, Thorbahn suggested, lay the Susquehanna's "mysteries":

> *For instance, there is the story of an underground canal leading from some unknown point in the bottom of the river and joining another stream many miles distant. Logs have been seen to disappear in a whirling foam, never to be seen again...Although no concrete evidence of such a pool or channel has been discovered, it is possible that ice could float about in a basin of this kind for months before finally being disgorged into the river.*

Stories about deep or even bottomless holes in the Susquehanna date at least to the late nineteenth century. The most famous of these depressions is "Job's Hole," beneath the river just above Conowingo Dam. Half a century ago, a fishing guide told Carl Carmer, author of *The Susquehanna*, the most flamboyant story about Job's Hole. "Friend o' mine is sort o' hasty an' one night on the road near Job's Hole his car stalled an' he couldn't git it started," said the guide.

> *Made him so mad he got a friend to help him—they was both drinkin'—and they pushed that thing over the edge into the hole. Six months later he was to Baltimore an' he seen his car, license an' all, rollin' to a stop. So he asks the feller drivin' it howcome an' the feller says he just happened to see it lyin' in shallow water near the mouth of Chesapeake Bay and fished it out.*

Job's Hole really does exist, but it is not bottomless. It is one of six "deeps" carved out by exceptional water flows along the eastern shore of the lower Susquehanna. These deeps, ranging up to 130 feet deep and 500 feet wide and running up to two miles long, were measured after portions of the river bottom were exposed during dam building. Ice might have formed in one of these deeps, but it probably would not have remained there into August. The river periodically scours sediment from the depressions and would do the same with ice.

All of this made a good newspaper story. H. Clifton Thorbahn reported that it made good temporary celebrities as well. Rankins and his assistant, Roy C. Kleinhans, became known as "the big coal and ice men of Shenk's Ferry."

LLOYD MIFFLIN FOLLOWED THE SUSQUEHANNA

Watching Lloyd Mifflin sketch a rocky scene in the Susquehanna River's course near Chickies Rock in the summer of 1871, a young boy asked a bystander what the Columbia artist/poet was doing.

"He's painting them thar rocks out there," said the bystander.

The boy looked at the sketch, without comprehension. Then he walked closer to the river and peered this way and that at the rocks. He returned and addressed Mifflin directly.

"I can't see no paintin' on them thar rocks!" said the boy. "Ain't you the man what paints patent medicine on the rocks?"

"I explained my mission," Mifflin reported in the journal he kept during a journey down the river, "and wondered if I belonged to the same craft that occupied a Michael Angelo [*sic*] and a Turner."

The adventurous artist came across a number of such homespun characters during his tour along the Susquehanna by train and steamboat

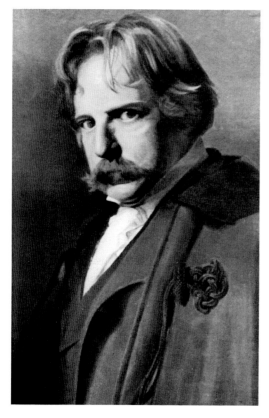

Columbia painter and poet Lloyd Mifflin. *Lancaster Newspapers.*

in August and September 1871. During a three-week, 460-mile trip from the Susquehanna's source in Cooperstown, New York, past his Lancaster County home to its mouth at the Chesapeake Bay, Mifflin's "mission" was to record the scenery. He completed over three hundred sketches, many from a window of his transport. The State Museum of Pennsylvania owns the sketchbook.

Mifflin also wrote regularly in his journal, which is in private hands and has not been published. The journal is a curiosity of Susquehanna River lore. Mifflin included some river description, but more often he spent his writing time fussing about the challenges of being a gentleman in America, how to dress well, how to be mannerly. Many of his Victorian observations seem overwrought today. For example:

> *The fragrance that leaves the rose makes the air sweeter though it makes the rose fade; so the redolence which exhales from the soil of the Poet, tho it sweetens the thought of the world, yet leaves him exhausted and near unto death.*

The exhausted Mifflin seemed to perk up and pay closer attention to the river itself as he neared Columbia. Or perhaps it was a "flood" that opened his eyes. As he sat sketching on the Pennsylvania Canal towpath near Harrisburg, a lock opened and spilled too much water, which, he reported, "washes us away."

Mifflin fantasized about floating past Chickies Rock in a boat, listening to a group of beautiful girls singing up there. "I anchor the boat and listen till the twilight deepens," he wrote, "and I lose the forms and only the voice remains, as it ever will." He intended to turn this idea into a poem.

At Safe Harbor, where the Conestoga River enters the Susquehanna, two boys offered to carry Mifflin across to the York County side for twenty-five cents. He declined. Mifflin acknowledged, "The little fellows got in their boat and, each taking a pair of oars, kept time like an Oxford Crew, skimming the boat along just above the edge of the rapids. I wished I had given them the quarter."

Along the canal at that place, Mifflin said he spotted a black snake with the hind legs of a frog sticking out of its mouth. The frog pulled out and headed in one direction, while the startled snake went the other way, Mifflin said, "one saved from a dinner and one a death."

At Peach Bottom, Mifflin described a river that no longer exists, the Susquehanna before power dams flooded its rocky shallows into deep

Lloyd Mifflin's photograph of his cousin, Martha Mifflin, on Chickies Rock, along the Susquehanna River south of Marietta. *Courtesy Lamar Libhart family.*

"lakes": "Peach Bottom…Hills low. River breaks thru with great force above and widens out into a lake. It averages 24 inches deep. Each year they mow a channel across for the ferry boat. Slate quarries. Best in the world."

Mifflin ended his journey on September 8, 1871, but his infatuation with the Susquehanna never diminished. Before his death in 1921, he sketched and painted scores of river scenes. He also wrote many sonnets with Susquehanna themes. Surely some of them were inspired by the 1871 trip. In one poem, included in a book of his sonnets called *The Fields of Dawn*, Mifflin imagined the river "singing": "I drain a thousand streams, yet still I seek / To lose myself within the Chesapeake."

Mifflin had seen many of those streams on his way to the bay that summer. A reader of his journal wishes he had described more of them in words while he was sketching river landmarks and rattling on about proper manners.

THE CITY OF LANCASTER

LANCASTER IN 1910:
A GOOD, SOLID, FAMILY TOWN

This piece, with apologies to Thornton Wilder, is called "Our Town, 1910."
 The name of our town is Lancaster, Pennsylvania. Lancaster is the central
city in a county with the same name. Our population (projecting from the 1900
census because figures from 1910 aren't in just yet) should be about forty-six
thousand. This is a good, solid, family town. It's conservative enough to fit in
with communities south of the Mason-Dixon line but contrary enough to stay
on this side. But our town is also progressive. Lancaster seems to have cast off
much of its quaintness with the turn of the century. We live in a modern city, with
trolley cars and a few motorcars, electric signs, factory whistles. The government
is pretty standard: mayor, nine selectmen, twenty-seven councilmen. All males
vote at the age of twenty-one. Women offer advice on how to vote.
 Our beloved, bewhiskered mayor is John P. McCaskey, everywhere known
as a progressive educator. He also composes songs, but probably not "Jolly
Old St. Nicholas," which some folks want to credit to him. William Walton
Griest, who runs the county's Republican organization, is our congressman.
Just elected him this year—in a landslide—even though the Democrats
claimed he was a flunky for Standard Oil.
 But this is a county of churches before politics. We have quite a few
Evangelical and Lutheran and Reformed. The Reformed operate the chapel

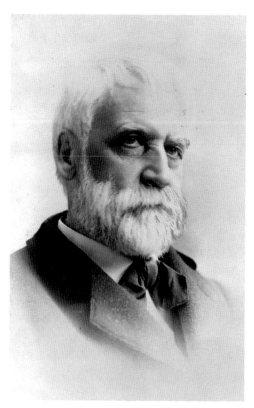

John Piersol McCaskey, mayor
of Lancaster, 1906–10. *Lancaster
Newspapers.*

at Franklin & Marshall College and Lancaster Theological Seminary across
the street. We have our share of Methodist and Presbyterian, Episcopal and
Catholic. And we have one of the oldest Jewish communities in the nation.
The Unitarians recently completed a building over on Chestnut Street.
Merchant M.T. Garvin was behind that. The rumor is that it's not really
a church at all but a "social club." It is, no doubt, whatever the Unitarians
want it to be.

We have five regular newspapers. Republicans read the *Lancaster New
Era,* the *Examiner,* the *Inquirer* and the *Morning News.* The Democrats have
the *Intelligencer.*

Lancaster ranks fourth in manufacturing in Pennsylvania, behind
Philadelphia, Pittsburgh and Reading. Armstrong Cork Company built
a huge new linoleum plant three years ago. Instructions to employees are
provided in English and Greek. The Follmer and Clogg Umbrella Company,
on West King Street, is probably the largest bumbershoot business in the
country. So Lancaster is known as the "umbrella capital of the world," a

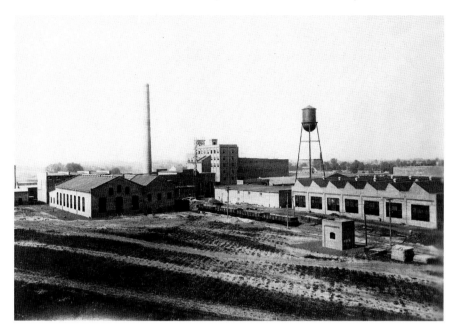

The Armstrong Cork Company floor plant opened in 1908. *Lancaster Newspapers.*

designation of dubious promotional value. The Stehli Silk Mill at Rossmere is the largest in the nation and second largest in the world.

The automobile has come to town in a big way. In 1907, S.G. Roth started up the National Automobile Company at Duke and Vine Streets. His ad says, "Automobiling is the king of sports and the queen of amusements," whatever that may mean. Among retail businesses, by far the most noticeable is the Woolworth building on North Queen Street. When it was built in 1900, it was the tallest commercial structure in the city. There's a fancy roof garden on top. The best restaurant in town is at S.K. Nissley's in the first block of East Chestnut Street. Nissley has a nationwide reputation for good "Dutch" food. If a beggar goes in there, though, the proprietor makes him read from the second chapter of Romans, before witnesses, before he'll give him a crumb.

There isn't a whole lot of culture in Lancaster. We have the Fulton Opera House for high culture and vaudeville and the nickelodeons for the rest of us. Stereoscopes and magic lanterns are popular. Of course, you can record your own entertainment. Over at the Columbia Phonograph Company, at 27 East Orange, you'll find this advertisement: "Do you sing? Do you recite? Put a Graphaphone before you and take a record of your own voice. We have

machines that do this perfectly. Complete with megaphone, mouthpiece, brush, needles, oil can and wrench kit."

Lancaster is a nice quiet town, with a sterling reputation—a perfect place to settle down and raise a family, many say—and most residents like it just that way.

LANCASTER'S TERRAIN: IT'S ALL UPHILL TO THE COLLEGE

The reason Lancaster City radiates from Penn Square is obvious to anyone who has tried to drive, from a dead stop on Prince Street, up the first block of West King Street on a snowy day: the center of town rests on a hill.

The reason for the location of the imposing Lancaster County Prison in the east end of town is equally obvious when you think about why the town's reservoir was sited in the nearby park.

The reason that Franklin College and Marshall College were combined on "College Hill" at the west end of town is not quite so obvious. But it's the

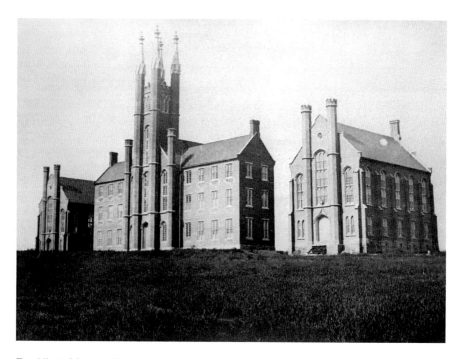

Franklin & Marshall College's first three buildings photographed in 1854, shortly after the colleges combined. *Lancaster Newspapers.*

same. Driving the mile from the center of town to the campus on College Avenue does not seem like a long pull uphill. You get a better sense of the incline while walking.

In fact, Old Main at Franklin & Marshall (F&M) sits on the highest point in Lancaster City and its immediate suburbs. It's higher than Cabbage Hill, higher than Reservoir Park. That's why the former Buchanan Park water towers were erected in the 1920s smack behind Old Main. F&M's administrators and trustees deliberately chose the high ground in 1853—the year that Franklin (1787) and Marshall (1836) marshaled their resources at a new site. The trustees considered several possibilities before making a selection. One was near the elevated site of the county prison. James Buchanan, president of the trustees and soon to be president of the United States, was relieved that that site was rejected. "I do not think the best location for a literary institution," he said, "is between the courthouse and the jail."

Still, F&M left some of itself in that vicinity. The college's 1886 yearbook defined Lancaster briefly as:

A town situated a short distance east of F&M College, on both sides of the Pennsylvania Railroad. It packs tobacco and makes cigars. It has a monument and a jail. It honored the college by naming the streets on each side of the jail Franklin Street and Marshall Street respectively.

At the laying of Old Main's cornerstone, Henry Harbaugh, a Marshall College graduate and pastor of First Reformed Church, praised the location in the west end of town: "Thank God! The college stands higher than the jail. Education must be lifted up and let crime sink to the lowest depths."

Other folks thought the trustees had lost their marbles. The campus was located in the midst of farm fields, well removed from the relatively small central core of Lancaster. James Street, the primary thoroughfare to campus, contained few homes and no permanent paving materials. "The place had a peculiarly desolate appearance," noted F&M historian Joseph Henry Dubbs in his 1903 history of the college, "and it was boldly asserted that trees would never grow upon that barren hill."

Well, trees have grown, to respectable heights, and it's still all downhill from there.

WHEN DID MAPMAKERS ADD THE CITY TO THEIR CHARTS?

When did mapmakers first include Lancaster in their designs?

Luis Freile, map librarian at R.R. Donnelley & Sons' cartographic services office on West James Street, searched for an answer. He consulted a 1929 edition of *Winston's New and Complete Atlas of the World.* The U.S. map, drawn by Collier's, included Chester and Reading but no Lancaster. Maps made in 1934 by Rand McNally and Hammond also contained no Lancaster.

Freile examined some more recent atlases. A 1943 *Rand McNally World Atlas* map of the United States did include Lancaster. The city's name also was printed on 1953 maps in Goode's and Collier's world atlases. But it was missing in Rand McNally's 1953 atlas.

So the pattern is clear: many U.S. maps drawn in the 1920s and '30s did not include Lancaster. Most, but not all, maps drawn in the 1940s and '50s did include Lancaster. What provoked the change?

Freile said he believes the Pennsylvania Railroad's new and improved station in 1931 may have helped put Lancaster on the map. Before that, he suggested, "Lancaster was known as an agricultural center, and a lot of agricultural towns were left out on those old maps." Lancaster historian John W.W. Loose provided a second opinion. Loose doubted the railroad theory; he said the earlier downtown station was well known. "I'd be more inclined to think that moving the corporate headquarters of Armstrong to Lancaster in 1929 would have done it," he explained. Both men said that a number of other factors might have contributed to placing Lancaster on the map. The growth of metropolitan Lancaster certainly was a factor. Tourism spread the town's fame. Mapmakers tend to copy one another, so once Lancaster was on the map, it stayed there.

Today, it's hard to imagine any mapmaker skipping Lancaster. The city is the center of one of the relatively few steady-growth metropolitan areas in the Northeast. Lancastrians in the 1920s and '30s may have thought their town inferior when they couldn't find it on maps, but today they are reassured when they peer into any contemporary atlas and see their town put in its place.

HOW LANCASTER BECAME ONE OF THE DENSEST CITIES

A city's population density can change dramatically over time. Lancaster's has. Until annexation began in the late 1940s and early '50s, Lancaster City contained four square miles. A pedestrian walking from Penn Square precisely one mile east, west, north or south would step on the municipal boundary. This square had a population density of 14,831 persons per square mile at the census of 1950. Lancaster was the eighth most densely populated city in the United States.

Promoters of annexation said Lancaster needed relief from overcrowding, but that's not the main reason the city took over large chunks of West Lampeter, East Lampeter and Manheim Townships. Annexation provided a wider tax base.

One might think the pre-annexation density of Lancaster evolved over considerable time rather than occurring within a few decades. A passage in the 1913 state convention book of the Travelers' Protective Association suggests otherwise:

> As long as federal censuses have been taken, Lancaster has been preeminent as a city of homes. For seventy years it has been the first of the hundred leading cities in the United States in the low average of people to a single dwelling. Davenport, Iowa, is the only considerable town that approaches it in this respect. In one of the most fashionable squares of Lancaster twenty-two capacious three-story houses are occupied by only forty-five persons. In other districts the per capita is greater; but, all in all, it may be safely asserted that nowhere in America is there a town or city, any where between twenty-five thousand and one hundred thousand population, in which there is the same household space to the inhabitants.
>
> Its area of kitchen, parlor, dining-room, dormitory and bathroom, per capita, is notably above these conditions in any other city in the country.

What happened between 1913 and 1950 to so alter the density of Lancaster's population?

Lancaster historian John W.W. Loose said housing needs during the Depression and World War II dramatically changed the city's density. Many homes in Lancaster's fashionable neighborhoods on North Duke, South Queen, West Orange, West Chestnut and East Orange Streets were broken

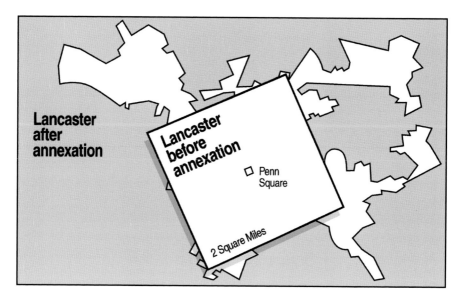

Annexation in the late 1940s and early 1950s reduced the density of Lancaster City. *Map by Chris Emlet.*

into apartments during the Depression. This considerably increased the city's density. At the outbreak of World War II, a need to house defense plant workers downtown accelerated the process. Those large homes that had resisted conversion were "apartmentized." Loose added:

> *I rather suspect the "fashionable square" cited for its twenty-two mansions containing forty-five persons was the square bounded by West Chestnut, North Charlotte, West Walnut and Lancaster Avenue. A few of those homes were (and are) fine large semi-detached town houses; the rest are single-family, free-standing homes.*

Annexation of less densely occupied suburban territory, coupled with an actual population decline, dramatically altered Lancaster's density once again after 1950. From a density of 14,831 persons per square mile in 1950, the city dropped to about 8,300 per square mile in 1960. As the population has fluctuated in more recent years, that density has risen and fallen, but never so dramatically as before and after 1950.

ROADS, STEAMBOATS, RAILROADS AND TROLLEYS

GREAT WAGON ROAD LINKED LANCASTER WITH THE SOUTH

The most heavily used road in colonial America, the one along which thousands of Pennsylvanians traveled to settle in Virginia and the Carolinas, probably did not pass through Lancaster County Central Park. But in that verdant setting, for the sake of convenience as much as anything else, a historical marker tells the road's tale.

The green metal marker stands across Golf Road from the site of an archaeological dig that uncovered American Indian graves in 1979. The heading on the marker, "Great Indian Warrior Trading Path," is confusing. The actual name for the road that passed somewhere in this vicinity is explained at the bottom of the marker text: "The Path was called the Great Philadelphia Wagon Road and passed by Philadelphia, Lancaster, York and Gettysburg." The path also was called simply the Great Wagon Road and ran all the way from Philadelphia to Augusta, Georgia. During the eighteenth century, tens of thousands of Americans traveled along that highway in search of more plentiful and cheaper land. The Great Wagon Road explains why there are so many Mennonites in Virginia's Shenandoah Valley and why Pennsylvania's Moravians established a settlement at Salem, North Carolina.

In 2001, Mrs. Raymond Hepler Jr., president of the National Society Daughters of the American Colonists (NSDAC), decided to erect one marker

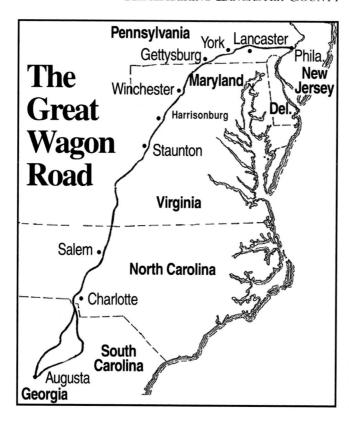

The colonial Great Wagon Road ran through Lancaster on its way to Augusta, Georgia. *Map by Chris Emlet.*

in each of the states through which the Great Wagon Road passed. North Carolinians Thomas and Martha Clark paid for the Pennsylvania marker. In exchange, they asked that it be placed somewhere in Lancaster County. Mrs. Clark's ancestors had used the road to get from Lancaster to Virginia and North Carolina. Clark ancestors John and Mary Elizabeth Schneido and their eight children left their home in Warwick Township in the spring of 1769 and followed the Great Wagon Road to Montgomery County, Virginia. Other ancestors later traveled to Moore County, North Carolina. Mrs. William Daugherty, of Clarion, then NSDAC regent of Pennsylvania, scouted for possible marker sites with the Thomases.

"I thought, my word, you can't just go out and stick a sign in the ground anyplace," said Mrs. Daugherty.

She and the Clarks settled on the park as a protected public place, and Ms. Daugherty visited the site with Paul Weiss, assistant park director. "He and I thought it would be appropriate to place the marker near the archaeological site, where the remains of twelve Native Americans and artifacts were

discovered," said Ms. Daugherty. So that's why the marker is there and not in downtown Willow Street or the Watt & Shand quadrant of Penn Square or any other place in Lancaster County.

No one knows precisely where the road passed through the county, but wherever it ran, it had a long and colorful history. Some imaginative people claim it followed ancient trails made by herds of mammoths and other ice age animals, which seems a far stretch. The DAC marker says the road was "laid on ancient animal and Native American Trading/Warrior Paths." The Indian trail part seems more plausible, although difficult to prove. Paul Wallace's *Indian Paths of Pennsylvania* lists only one trail—the Great Minquas Path—that might apply. That trail ran from Philadelphia through Willow Street and Conestoga Indian Town to Washington Boro. The DAC marker claims a Great Indian Warrior Trading Path linked the Great Lakes to Georgia. But a distinct Indian path that wound from Lake Erie southeast to Philly and back west to Gettysburg before heading south seems unlikely.

In any case, the DAC memorialized Indian trails and the Great Wagon Road with a handsome sign in Central Park on September 29, 2001.

Here's to one of America's great highways, now obliterated and replaced by many more ribbons of asphalt crisscrossing this splendid land once traversed by woolly mammoths, moccasined Indians and wandering wagoners.

STEAMBOATS INVENTED HERE BUT
NEVER TRAVELED FAR

In an age when computers are creating robots, it may seem quaint to discuss the origins of steam navigation. Two of the four men most closely associated with the beginnings of steamboats hailed from Lancaster County, however, so the topic may be of some interest.

Robert Fulton, a native of Little Britain Township in southern Lancaster County and namesake of Lancaster's old opera house, is popularly credited with "inventing" the steamboat. This is largely because he operated the first successful steamboat service in the world in 1807. John Fitch, who was not born here but visited, ran a steamboat between Philadelphia and Trenton seventeen years before Fulton's *North River Steamboat* (later known as the *Clermont*) plied the Hudson. That boat lost money. James Rumsey, who was not born here and, so far as is known, never visited, floated a steamboat on the Potomac

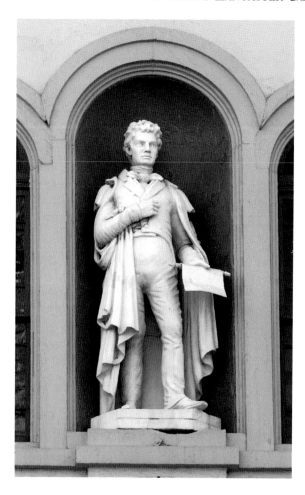

This sculpted figure of Robert Fulton, inventor of the first successful steamboat, stands above the marquee to Lancaster's Fulton Opera House. *Photo by Rick Hertzler.*

River some three years before Fitch's boat steamed up the Delaware. Rumsey and Fitch argued for years over who should get credit for the invention.

Another Lancastrian, scientist and mechanic William Henry, made a steamboat many years before any of the others. He traveled to England in 1761 to meet the Scottish inventor James Watt and, two years later, designed a stern-wheel steamboat. He tested it on the Conestoga River. The vibrating steam engine knocked the boat apart. Henry was busy with other activities—gunsmithing, inventing the screw augur, surveying a canal route between the Susquehanna and Lehigh Rivers, serving in the Continental Congress—and never got back to the steamboat. He happily shared his designs with Fitch when that inventor came calling. Henry also inspired Robert Fulton. As a teenager, Fulton visited Henry's machine

shop to see the gunsmith's large collection of inventions. He spent time in the Juliana Library (predecessor of the Lancaster County Library), which Henry managed.

With all of this discussion about steam navigation going on in Lancaster, one might think one of these men would have tried to float a steamboat on the Susquehanna. They were smarter than that. The shallow, rocky Susquehanna is not navigable. They took their boats to deeper water. If he had not lost interest in the project, Henry also might have made a better boat for deeper water. The Conestoga is as shallow as the Susquehanna. If Henry's steamboat had not vibrated itself to death, it probably would have gotten stuck in the mud.

Three steamboats did successfully use a small portion of the Conestoga more than a century after Henry's failed experiment. The most famous of them, the *Lady Gay*, carried passengers from Witmer's Bridge to People's Park and Rocky Springs between 1890 and 1915. Boats also steamed for short distances on the Susquehanna, both here and elsewhere along the river's course from Cooperstown, New York, to the Chesapeake. Two steamboats, the *Helen* and the *Mary*, operated out of Columbia through the early years of the twentieth century.

But the fate of long-distance commercial navigation on the Susquehanna had been settled much earlier when three steamboats designed to conquer the difficulties of the shallow waterway utterly failed. The boats were the *Susquehanna*, the *Codorus* and the *Pioneer*. The *Codorus* was built at York and the other two boats at Baltimore. The owners kept them at York Haven over the winter of 1825–26, and each voyaged upriver early in the spring. The *Susquehanna* ran up to Northumberland and back in March. The *Codorus* headed up the river's North Branch as far as Binghamton, New York. The *Pioneer* traveled the Susquehanna's West Branch to Williamsport and Jersey Shore.

Large crowds greeted the steamboats as they passed each town along the way. Bands played stirring music. Cannons blasted charges over the water.

The *Susquehanna* returned to this area and made a second voyage upriver in late April, which turned out to be a really rotten idea. The boat got the same send-off—the citizens of Marietta launched fireworks, for example—but spring rains had swelled the river, adding to the danger. At Nescopeck Falls, between the villages of Berwick and Nescopeck on the river's North Branch, the *Susquehanna*'s crew added wood to the fires beneath its steam-making boilers and headed for a central channel through the white water. About two-thirds of the way up the channel, the boat lost momentum. It drifted back to the foot of the rapids and struck a large rock on shore. One of the boilers exploded

at both ends. The burst of boiling water killed two men. Another died a few hours later. The boat's engineer expired the next day. Exploding water scalded the fireman and several passengers.

Battered but reparable, the *Susquehanna* returned to York Haven. So did the *Pioneer*. Stranded in New York by low water, the *Codorus* finally ran down the river when rain fell in mid-July. None of these boats ever steamed on the Susquehanna again. Prompted by the opening of the Erie Canal, Pennsylvania began constructing canals throughout the state in the late 1820s. Dams running all the way across rivers channeled water into the adjacent canals. They also permanently blocked long-distance steamboat travel by river.

LOW-GRADE LINE WAS AN ENGINEERING TRIUMPH

At high noon on July 27, 1906, Quarryville hardware dealer and Slumbering Groundhog Lodge founder George W. Hensel Jr. grabbed a long-handled, silver-plated hammer made by blacksmith Owen Bremmer and pounded the last spike (also silver, also by Bremmer) into the Atglen and Susquehanna Branch of the Pennsylvania Railroad. Several hundred laborers, many of them Italian, Turkish and Syrian immigrants, applauded the effort. Some of these men had spent more than three years blasting a path through hills and driving spikes into rails running from Atglen, Chester County, through Quarryville to Creswell Station on the Susquehanna River.

A contemporary account says that many men died while leveling the countryside to form the freight line that has become known as the Low-Grade Line. Eleven expired when a dynamite factory exploded seven weeks before the driving of the final spike. The survivors, having worked through that last summer to complete the job, doubtless believed they had suffered enough.

After Hensel finished his part of the spike-driving program, Anna Acheson, daughter of one of the assistant project superintendents, cracked a bottle of champagne over a rail. As glass shards settled on the rail bed, Miss Acheson said, "I dedicate this enterprise to the uses of humanity and to the glorification and development of God's chosen country—the Lower End of Lancaster County." The crowd cheered. A photographer peered through his lens. When the laborers spotted the photographer, a news account notes, "they almost went wild, so anxious were they to be in the pictures."

George Hensel, Anna Acheson, other dignitaries and all of the laborers on hand for the spike-driving and dedication of the Low-Grade Line through Lancaster County no doubt would be surprised to learn that the railroad

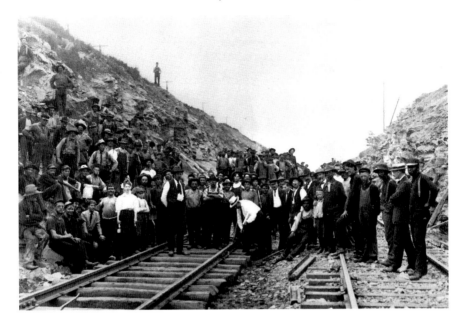

As laborers watch, Quarryville merchant George W. Hensel Jr. drives the last spike on the Low-Grade Railroad, July 27, 1906. *Lancaster Newspapers.*

eventually would abandon this engineering triumph. They would be even more astonished to hear that the ultimate fate of the Low-Grade was the subject of a lengthy disagreement between those who wanted to turn it into a hiking and biking trail and those who wanted to let individuals purchase parts of it for their own use. We might assume they would be pleased that the trail won the argument.

The point of all the labor that ended in the summer of 1906 was to develop a railroad line with no slope steeper than 1 percent and no curve sharper than two degrees. Pennsylvania Railroad president A.J. Cassatt designed the line so that it cuts into the ground or is artificially elevated to maintain that low grade. To do that, the Pennsy spent $19.5 million in Lancaster County blasting away tons of rock, filling in low areas and building dozens of impressive stone bridges under and over the rails. The full line runs through Pennsylvania and Ohio. Cassatt died the year the local section was completed or the project might have been extended across the country. Costly as it was, the line vastly improved railroad efficiency.

Lancastrians were impressed by the achievement. The semiweekly *Lancaster New Era* expressed some of that awe in an editorial in the August 1, 1906 edition:

The readers of the technical journals may be more or less familiar with the details of the enormous blasts which shattered the hillsides along the east bank of the Susquehanna, the heroic expedients to which contractors were forced to bring their men and machinery to bear on roadway building in remote and inaccessible hill country, and the vast fills which had to be made to elevate tracks above the level of Susquehanna floods and ice gorges. But the traveling public will know nothing of all these things. The new line will be used exclusively for through freight traffic.

The general public, then and now, could not know the full extent of the engineering miracle that was wrought on the land between 1903 and 1906 in southern Lancaster County. Those assembled for the spike driving knew, though. And by high noon on a very hot summer day, they surely were eager to get out of there and let the trains run.

HOW THE HIGHWAY ROBBERS KILLED TROLLEY SERVICE

On September 22, 1947, trolley service ended in Lancaster County. The last Lancaster trolleys ran from downtown Lancaster to Rocky Springs amusement park. Restored, one of those trolleys operates on a short track in Manheim today.

Almost precisely fifty-three years after the trolleys died—on September 21, 2000—Penn Township's supervisors agreed to rezone 268 acres of farmland so that the Manheim Auto Auction could more than double its space for parking automobiles just outside Manheim.

The coincidence in timing of these two events, along with the coincident location in Manheim of both Lancaster County's last trolley and its largest automobile parking lot, invite a story. Here's how boosters of the internal combustion engine killed electric trolleys.

Street railway transportation in Lancaster County began in 1874 with a streetcar that replaced the stagecoach traveling between Lancaster and Millersville. Horses drew the first streetcars. The line was electrified, and trolleys ran for the first time in 1891. The Conestoga Traction Company, predecessor of the Red Rose Transit Authority, soon was operating trolleys throughout the county. At the peak of service, forty trolleys ran through the city alone. Trolleys made nineteen trips to Manheim every day.

"The street car filled a vital transportation need before the coming of modern highways," wrote Columbia transportation historian John D.

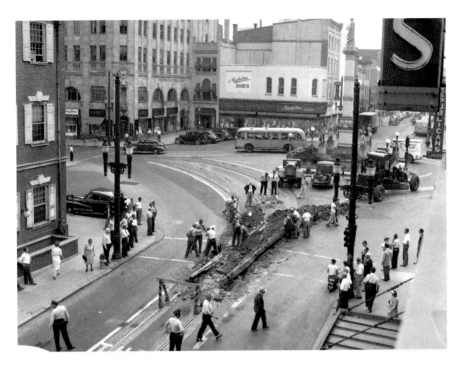

Workers remove trolley rails from Lancaster's Penn Square, July 14, 1947. *Lancaster Newspapers.*

Denny Jr. in his *Trolleys of the Pennsylvania Dutch Country*. "However, the trolley, regardless of its low fares and frequent schedules, could not compete with the convenience of the private automobile."

Buses began replacing trolleys here in the early 1930s. Patronage fell radically, and the CTC abandoned the last trolleys—the Rocky Springs and Seventh Ward trolleys—in September 1947, according to Luther P. Cummings and Benson W. Rohrbach in *Garden Spot Trolleys*. The same thing happened all across the United States at about the same time, not only because trolleys could not compete with the convenience of buses and cars, but also because auto and tire makers, asphalt producers and petroleum companies actively undermined street railway transport.

Trolleys dominated transportation in the early twentieth century. People rode them to work, to visit friends and to get to parks like Lancaster's Rocky Springs. Interurban trolleys carried travelers between cities. Trolleys were ubiquitous. Automobiles were still relatively primitive and, just as horse-and-buggy drivers shouted, "Get a horse!" to stalled motorcars, trolley conductors laughed as they glided past frustrated owners of early cars.

All of this ended faster than those conductors could have imagined. The trolleys died partially because of mismanagement from within but treacherously because the highway transportation lobby conspired against them. The auto industry poured millions of dollars into ads promoting vehicular travel as superior to trolleys. The industry persuaded the federal and state governments to build a national network of highways, at taxpayer expense, to compete with trolleys, which usually were financed by private funds and fares.

But what really did in trolleys was the advancement of bus transportation. Roy Fitzgerald and his brothers began the bus revolution in Minnesota just after World War I. By 1925, their Range Rapid Transit Company was running twenty-five buses. They steadily expanded this system throughout the Midwest and West. Then the brothers began buying trolley lines and replacing them with buses—a process they found very profitable. Concerned about temporarily stagnant auto sales and inspired by the Fitzgerald brothers' success, General Motors supported Roy Fitzgerald in an effort to eliminate electric transportation and introduce more buses and cars. Operating under the name National City Lines, GM and Roy Fitzgerald conspired to create a motor monopoly in nearly four dozen cities. With financial backing from Greyhound buses, Firestone tires and Standard Oil, they took over more than one hundred trolley lines. They dismembered a practical and economical transportation system and replaced it with buses that were more expensive to operate and spewed pollutants into urban air.

Most of Lancaster County's trolley lines began converting to buses without direct intervention by the highway robbers, but no doubt the pro-bus bias boosted by the conspirators influenced CTC's decision to begin abandoning trolleys.

Like their counterparts in other cities, by the mid-'40s, Lancastrians had little choice but to take the bus or buy their own cars. Car sales soared. So did the postwar, automobile-driven stampede to suburbia.

The Sherman Antitrust Act forbids companies from combining forces to restrain a competitor. Belatedly, in 1949, federal prosecutors in Chicago charged the highway conspirators with colluding to monopolize the sale of buses, petroleum products, tires and tubes. A trial convicted all parties, a verdict upheld on appeal. In *Road and Rail: The Epic Struggle between Road and Rail in the American Century*, Stephen B. Goddard writes:

> *Yet for their roles in concocting and perpetuating a criminal conspiracy—which helped change the dominant urban energy from*

electricity to less-efficient petroleum and to alter American life forever—the Court fined the corporations five thousand dollars each and the individuals one dollar.

Big profits had been made, much bigger money would be made and there was no turning back. Buses paved the way for cars, and cars quickly became the predominant mode of travel in the United States. And that is why, in Manheim today, thousands of automobiles of one of Lancaster County's most successful businesses sprawl over hundreds of acres, while the last trolley runs back and forth as a quaint curiosity on 150 feet of track at the Manheim Railroad Station.

WATT & SHAND, WOOLWORTH'S, AND THE BRUNSWICK

WATT & SHAND BUILDING LINKS TWO CENTURIES

As downtown Lancaster's last department store prepared to close forever in March 1995, some patrons may have plotted to be the last to purchase a necktie in the men's clothing department or the last to eat lunch at the Rendezvous or, perhaps, the last to walk out the front door.

The Bon-Ton's last customer did not receive an armful of flowers, but the store's first did. Ella Fox, of 45 South Duke Street, received her bouquet from Watt & Shand, the Bon-Ton's predecessor at the Penn Square site, on March 4, 1928. That was half a century after Mrs. Fox had spent five dollars for an all-wool plaid shawl—the first item ever purchased at Watt & Shand. Mrs. Fox told a newspaper reporter in 1928, as she was being honored by the store:

> *You can't imagine the difference between this store and the one I walked into 50 years ago. There weren't big, endless counters and glass cases of pretty things to look at then. A customer came into the store in those days and asked to be shown a certain thing and nine times out of 10 he didn't have any big selection to fidget over. You either took it or left it. It was just buying in those days. Shopping was something that came later when the selection of merchandise was widened.*

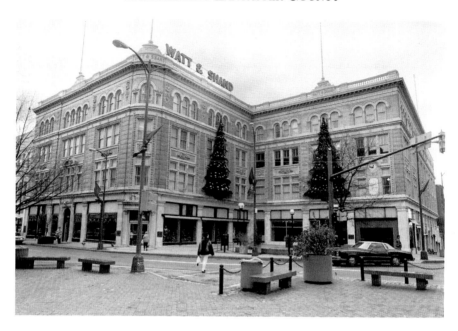

Watt & Shand department store on Lancaster's Penn Square, photographed in December 1989, six years before it closed. *Lancaster Newspapers.*

The old department store has changed radically since Mrs. Fox bought her wool shawl on March 9, 1878. Following years of fractious debate and delayed construction, the Watt & Shand façade became the base around which a public-private partnership completed the expensive and expansive Marriott Hotel and Lancaster County Convention Center on Penn Square in 2009.

Watt & Shand's beginnings were much more modest. The original store, founded by three Scotsmen—Peter Watt, James Shand and Gilbert Thompson (who died the next year)—occupied a room that measured thirty feet by sixty feet. The staff numbered nine, including Watt, Shand and Thompson. All customers were required to pay cash. That store was located at 20–22 East King Street, on the site of a defunct enterprise called the New York Store. The enterprise succeeded and quickly expanded into adjoining buildings closer to Penn Square. In 1898, Lancaster's best-known architect, C. Emlen Urban, designed a four-story structure of light gray brick, terra cotta and marble—the core of the present store. Several major expansions in the twentieth century wrapped Urban's façade around other buildings along East King and South Queen.

The department store operated by James Shand and Peter Watt gained a reputation for catering to a certain clientele. Lancaster historian John W.W.

Loose recalled a story his mother told about shopping at Watt & Shand as a young woman in the early 1900s. Watt & Shand remained "the New York Store," while Hager's was "the Lancaster Store" and Leinbach's was "the Boston Store." Loose's grandmother shopped at Leinbach's and told her daughter, Loose's mother, to do the same because of its more acceptable image. "Social lines were drawn," Loose said. One day, Loose's mother crossed that line and purchased clothing at Watt & Shand. "She went there anyway and got a talking to from my grandmother," Loose said.

As Watt & Shand's popularity and size increased, its departments did likewise—to twenty in 1913 and more than sixty in 1963. Some of those departments—such as men's and women's clothing—were enlarged considerably. Others—such as the toy department—diminished in size.

James Shand, former Watt & Shand chairman and a grandson of the founder, recalled that one of his first jobs at the store in the late 1940s was as an assistant to the buyer in the toy department. "That was a disaster," Shand said.

It was a short selling period. Ninety percent of our business was right there at Christmas time, and we had about a month to sell. We had to have the right inventory and then we had to be sure that we did not have a lot left over the day after Christmas. Every night you were readjusting your displays and your direction.

From the beginning, the store geared its window and interior displays to a variety of customer interests. In 1898, for example, a naturalist showed fifty thousand specimens of rare birds on the second floor. In 1908, shoppers were treated to a "free exhibition" of a painting by Rosa Bonheur valued at $45,000.

Over the years, Watt & Shand provided a number of firsts in Lancaster retailing. It was the first local department store to set a price for goods and to refuse to bargain for lower amounts (1878), the first to employ a cash carrier tube system (1915) and the first to install escalators (1949). In 1992, Watt & Shand became the first downtown department store to be purchased by a company from outside Lancaster County. The Bon-Ton stocked different merchandise and, to the chagrin of sales clerks, brought in new cash registers that were difficult to operate.

While Lancastrians persuaded the new owners not to dismantle the familiar yellow neon Watt & Shand sign on the store's roof, they lost on the issue of chairs, which the previous owners had maintained for customers

waiting for buses at the South Queen Street entrance. Lancaster attorney Bill Arnold recalled these chairs in verse:

On our trip to Bon-Ton, our chairs were all gone
On which we would wait for our bus—
Which made us all mad, thinking removal had
Been directed espec'ly at us.

By the time the Bon-Ton locked its exits for the final time, all the chairs were gone and all the cash registers were silent. The Bon-Ton joined Leinbach's, Hager's, Garvin's and Hess's as another "former downtown department store." But it was the last—and so has been missed all the more.

RECALLING BETTER DAYS FOR WOOLWORTH'S FIVE-AND-TEN

I met a million-dollar baby in a five-and-ten-cent store.
—song during the Great Depression

After 118 years, time is running out.
—sign in window of Woolworth's in downtown Lancaster, October 1997

Surrounded by treasures collected from a life of service as professional fundraiser, freelance writer, volunteer and wife of a traveling army engineer, Rheta Cohen Stacy moved into an apartment at Brethren Village in the autumn of 1997. Among the first belongings she arranged in her new living area were a couple of carefully crafted children's wood chairs, a leather doll with movable arms and legs, a chocolate pot with cups and plates and a candy scale with brass weights.

All of these simple but elegant items had been purchased in F.W. Woolworth's five-and-ten in downtown Lancaster nearly a century before. Mrs. Stacy's grandfather, Henry H.M. Werner, had worked there as window decorator and assistant manager. Woolworth himself gave the doll to Mrs. Stacy's mother.

"I just hate to see this part of history go," said Rheta Stacy, whose own plentiful Woolworth memories complemented her grandfather's and mother's.

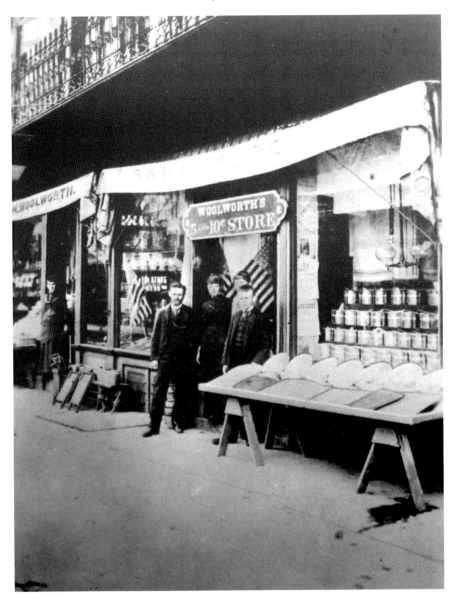

Employees stand outside F.W. Woolworth's first successful five-and-ten at 170 North Queen Street in 1879. *Lancaster Newspapers.*

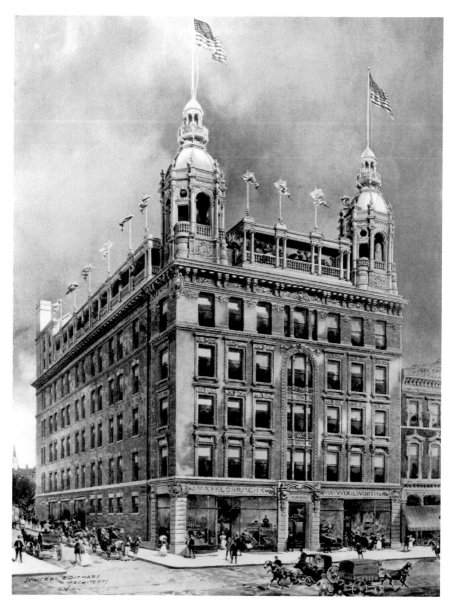

A 1900 architectural drawing of Woolworth's five-story store, with gold-domed towers and roof garden, at 21–27 North Queen Street. *Lancaster Newspapers.*

What was left at the quickly going-out-of-business Woolworth's store on North Queen Street in October 1997 did not rival Mrs. Stacy's leather doll and cocoa cups. In an expansive space that once sheltered tons of varied merchandise, curious customers found the dregs of greeting cards, cheap Christmas ornaments, Rubbermaid containers, flea collars, breast pumps and Buttmasters—the flotsam and jetsam of Woolworth retailing at 60 to 80 percent off. Woolworth stores here and all across America were closing down forever.

It all began on a far brighter note in 1879 at 170 North Queen Street (now part of Lancaster Square). Frank Woolworth was determined not to repeat the failure of his first "Great Five-Cent Store" in upstate New York. In Lancaster, he succeeded famously. He expanded and marked up his merchandise, creating the first five-and-dime store in the world. He also was the first merchant anywhere to allow customers to touch products before buying.

As he opened stores elsewhere and moved to New York to coordinate a nationwide retailing empire, Woolworth retained a special interest in the Lancaster operation. In 1900, he built a spectacular five-story building with gold-domed towers and a roof garden ("the Coolest Spot in Town") at Woolworth's current location, 21–27 North Queen.

Henry Werner had begun dressing windows at Woolworth's the year before. Window trimming is not much of a trade these days, but a century ago it was the soul of retailing. Werner created monumental displays in Woolworth's windows—the sort of thing people would journey from Falmouth and White Horse to ogle. Before he retired as assistant manager of the Lancaster store in 1921, Werner had gotten to know Frank Woolworth very well. Rheta Stacy said her grandfather spoke of eating lunch in the roof garden with Woolworth and Milton Hershey, who manufactured caramels in Lancaster before moving on to build his chocolate factory and create the village of Hershey in 1903.

"I remember as a child, after my grandfather had retired, he took me to Woolworth's and all the clerks knew him, and I got bags of candy," said Mrs. Stacy. "When I was going to McCaskey (in the mid-'40s), we would go there after school and have fifteen-cent chocolate sodas."

Besides the doll and other items purchased at Woolworth's, Mrs. Stacy preserved photographs her grandfather took of the store's early days. Many were made in 1911, when the redecorated five-story store held a grand reopening.

"I remember my grandfather talking about how Woolworth's changed after Mr. Woolworth died (in 1919)," Mrs. Stacy said. "It just wasn't the same Woolworth store anymore."

Reduced to its current nondescript two-story shell in 1950, Woolworth's was nickel-and-dimed to death by over-abundant competition. The last shoppers in 1997, rummaging in the pathetic remnants of what once was the world's greatest variety store, even had an opportunity to purchase the display racks. But the best items had been sold soon after Woolworth's began shutting down all four hundred stores nationwide. The huge photographs of F.W. Woolworth, the first Lancaster store, the five-story store and other local landmarks that hung high on the north wall—proud reminders that it all had begun here—sold first.

Rheta Stacy believed her grandfather had produced those pictures. She lamented their passing, along with the five-and-dime empire her grandfather had helped F.W. create.

BRUNSWICK SOLD SHOOFLY PIE À LA MODE FOR THIRTY-FIVE CENTS

An old Brunswick Hotel menu reminds us that, when that place closed and it and the rest of the second block of North Queen Street were bulldozed in the 1960s, downtown Lancaster dropped a notch or two in class. The ridiculously low prices on this menu, dated August 21, 1956 (chicken corn soup: $0.20; complete lobster dinner: $2.60; shoofly pie with ice cream: $0.35), stir fond memories of where Lancastrians ate these and other treats.

Paul Heine built five restaurants in his hotel in the 1930s. He popularized seven sweets and seven sours. His mock turtle soup became famous. Lancastrians could enjoy a cocktail in style in the swank Baron Stiegel Room. The Brunswick's mahogany-paneled lobby reflected not only Heine's sense of taste but also his eclectic interest in antiques. Who could forget the cigar store Indian with a red light built into its head?

Many older Lancastrians remember the lobby, the restaurants and other public places in the Brunswick because they spent as much time there as visitors did. But tourists came in large numbers to use the hotel's two hundred rooms, all of which had radios in 1956. Many had TV and air conditioning. These amenities were crucial to Paul Heine Jr., who took over management from his father in 1947. Heine helped launch Lancaster County's tourist industry in the 1950s. He knew he needed to woo visitors from New York City with a first-class hotel.

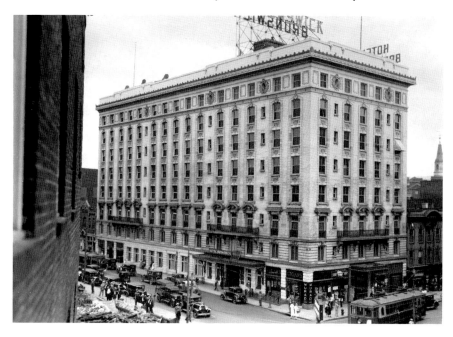

The Brunswick Hotel as it appeared in the 1930s. *Lancaster Newspapers.*

He needed a first-class hotel with a recognizable symbol. The symbol was "Yonnie," a drawing of an Amish man with a broad-brimmed hat, waving to visitors or sitting on a bench eating the latest Brunswick stew.

The junior Heine helped create what would become one of the nation's largest tourist markets, but his Brunswick would not remain a part of the trade. He died in 1961, and after management ran the hotel into the ground, the building closed its doors in 1964. Workers demolished the Brunswick three years later as part of the clear-cutting operation of urban renewal in the second block of North Queen. Its replacement, an undistinguished Hilton Inn, faltered, was renamed the Brunswick under new ownership and has endured more renovations and closures.

Among many differences between the old and new Brunswicks is this: The old Brunswick had a front door, welcoming both Lancastrians and tourists to enjoy its hospitality. The present Brunswick has no front door. Unless one drives into the adjacent parking garage, one can find no obvious entrance. This is symbolic of the lack of respect for people that permeated urban renewal in the second block of North Queen. Another example: Hess's Department Store had uninviting entrances and insufficient display windows. That entire block of concrete was not

redesigned for human use, and now most of it has been replaced by more accessible buildings and parks.

This is getting heavy. Let's pause to enjoy a 1956 sundae, any flavor, with whipped cream: thirty cents. With nuts: thirty-five cents.

The old Brunswick's restaurants drew a steady clientele from Lancaster and throughout the world, while dozens of famous people stayed in the hotel's rooms. They included Ethel Barrymore, Joe Louis, John Philip Sousa, Marian Anderson, Eleanor Roosevelt and Vincent Price.

Older hotels had begun operating on that site before 1777, and many other well-known Americans had visited them before Heine built the Brunswick. Three presidents left railroad cars and made speeches from the balconies of these hotels. Abraham Lincoln spoke there on his way to Washington on February 22, 1861. James Buchanan addressed his fellow Lancastrians upon returning home two weeks later. Theodore Roosevelt talked at that spot in April 1912.

All of this history somehow seems tied to a simple 1956 menu, which includes a chef's platter of baked fillet of rockfish: one dollar; and a lime rickey in exchange for two dimes. And let's not forget old Mr. Five by Five, the Brunswick's king-size hamburger, at an economical sixty-five cents.

WITH DEMUTH SNUFF, YOU INHALED WHISKEY AND SOAP

If you want to make a large batch of Demuth family snuff, you'll need more than one hundred pounds of tobacco. You'll need three gallons of whiskey, a wheelbarrow full of various herbs and several cups of salt. Toss in a few bars of the finest soap. Blend and sniff deeply. Relaxed? OK, now here's more about the origin of that recipe.

The Demuth family of Lancaster is known primarily for two enterprises: tobacco and art. Several generations of the family produced and sold tobacco products on East King Street. The Demuth Tobacco Shop opened in 1770 at 114 East King and today is the oldest store of its kind in the United States. Charles Demuth, the eminent artist and last of his line, produced spectacular watercolors and other works at his home behind that tobacco shop early in the twentieth century. The Demuth Foundation, which owns the tobacco shop, Demuth's home and other properties in that vicinity, memorializes Charles Demuth and his art and the other activities of his family, including the manufacture and sale of tobacco.

The Demuth family made snuff and sold it in the Demuth Tobacco Shop at 114 East King Street. *Photo by Jack Brubaker.*

And so the directors of the foundation were surprised and pleased to discover rare Demuth snuff recipes in the summer of 1994 as they cleaned out the closets of a Demuth home at 116 East King, adjacent to Charles Demuth's house. Dorothea Demuth, whose husband, Christopher, was a cousin of Charles, resided at number 116 until her death in 1992. The foundation took control of the building and eventually housed its permanent collection of the artist's works there. But in 1994, the foundation had just found someone to rent the place. Therefore, a thorough cleaning was required. Bruce Kellner, professor emeritus of English at Millersville University and member of the Demuth Foundation board, discovered the snuff stuff in a first-floor closet.

Christopher Demuth, patriarch of his family, probably began manufacturing snuff in the late eighteenth century. The recipes prove that the Demuths were making snuff in massive amounts by the turn of that century. There are two meticulously handwritten recipes, for "Lancaster Snuff" and "Aromatic Catarrh Snuff." Catarrh is an inflammation of a mucous membrane, especially of the respiratory tract. This recipe apparently was to be used medicinally to, so to speak, snuff out the sickness.

Carol Morgan, then executive director of the Demuth Foundation, was amazed to find the handwritten recipes. The only other known recipe—for

Lancaster Snuff only—is typewritten and signed by Ferdinand Demuth, Charles Demuth's father. So these older, handwritten notes appear to be original recipes. They are signed "E.E. Demuth." The only Demuth with those initials is Elizabeth Eberman, wife of Jacob Demuth, one of Christopher's sons. Elizabeth Demuth lived from 1783 to 1805, which dates the recipes to the turn of that century.

"It's interesting that a woman would do the snuff recipe," Morgan noted. "Tobacco was primarily a man's thing, although women used snuff." (She said a nineteenth-century Philadelphia woman so regularly ordered snuff from the Demuth Tobacco Shop that she seems to have been addicted.)

The Demuths made snuff in a three-story brick manufacturing plant directly behind 116 East King. That building remains standing, with remnants of the snuff-making machinery inside. The family imported tobacco for this purpose. They may have used Lancaster tobacco to wrap the cigars they sold in their tobacco shop, but their snuff had to be, well, up to snuff. They employed only the "finest tobacco" from Virginia, Missouri and Kentucky.

The Demuth Foundation will not release the complete recipes, just as the Demuths carefully guarded them. Elizabeth Demuth wrote on the back of her note: "Give none of these recipes to Uncles or Cousins and keep them all secret." Including tobacco, whiskey, soap (to keep tobacco particles from sticking together), salt (to prevent molding) and various oils and herbs, the concoctions seem strong enough to open up the nasal passages, if not burn them out altogether.

"It would be very interesting to make some and see what it was like," commented Morgan. "See if you could stand it."

LANCASTER AT WAR

WAITING FOR HOSTILE INDIANS TO
SWEEP INTO TOWN

"Great Horror and Confusion" plagued Lancaster County and the entire Pennsylvania frontier in the autumn of 1755. Frightened residents heard daily news and rumors of nearby atrocities. American Indians allied with the French raided within thirty miles of the twenty-five-year-old English settlement at Lancaster. The Delawares reportedly boasted that they would make their winter quarters in the town.

"We keep a watch here every night of sixty men," a local leader said that November. "Our numbers are quite discouraging; and if the women who were in the greatest consternation should prevail upon their husbands to carry them away (and where can they go to?) we shall still be worse off."

Armed men gathered to defend the town at the slightest provocation. On one occasion, a man's servant created a false alarm by firing his pistol into some trees. Scores of men grabbed their rifles and ran to the old county courthouse in Centre Square. Concerned Lancastrians petitioned the provincial government for military assistance but received no immediate aid. The town's proprietor, Philadelphian James Hamilton, said he was surprised that Lancastrians should be "so terribly alarmed by a handful of Indians on the Frontier." Hundreds of concerned residents of the largest settlement

west of Philadelphia were dismayed to hear that, as far as provincial officials were concerned, they were on their own.

In the spring of 1756, a large number of settlers from frontier counties assembled in Lancaster and threatened to march on Philadelphia, hoping to force the Quaker-dominated government to do more to protect them. Officials persuaded the protesters to desist, but they were not happy about it.

Despite their concerns about safety at home, hundreds of Lancaster County residents rallied to arms, marching along with military expeditions and guarding frontier forts along the Susquehanna and Potomac Rivers. "Many of the savage atrocities of the French and Indian war were committed within what was then Lancaster County, though none were perpetrated within its present limits," wrote Franklin Ellis and Samuel Evans in their *History of Lancaster County*. "But the alarm was general in the lower, as well as in the upper parts of the county, and all the people (non-resistants excepted) rallied under arms for the general defense."

Lancaster was never hit directly, but to live here was to live at the center of the British military effort. "Conveniently located for communication with the east, and a gateway as well to the west, Lancaster was strategically important to the defense of the back country," wrote the late historian Jerome H. Wood Jr. in *Conestoga Crossroads*.

To protect the town and the region, the English eventually established an army base in Lancaster and launched two expeditions to the west, under Generals Braddock and Forbes. Hundreds of troops moved into the town, often staying with residents whether welcome or not. Lancaster was an arms storehouse and the surrounding county a breadbasket. Wagons filled with grain and other foodstuffs, with "beeves" walking alongside, shared roads with troops marching to challenge the French and their Indian allies.

Toward the end of hostilities, a calm settled over Lancaster County. A fierce threat had passed. Life could begin returning to normal. But then…

Lancaster's singular atrocity came immediately following the French and Indian War, as thousands of Indians rallied behind a charismatic chief from the Detroit area named Pontiac. Pontiac's Rebellion quickly swept east and into central Pennsylvania. In December 1763, a large group of men called the Paxton Rangers (because many of them came from the Paxton area of Dauphin County, then a part of Lancaster County) rode into Manor Township and killed six peaceful Indians in their camp at Indian Town. Fourteen Conestogas had been away from camp at the time of the massacre. Local authorities placed them in the Lancaster Workhouse, supposedly for their safekeeping. Two days after Christmas, the Paxton Rangers rode

into town, broke into the workhouse and slaughtered all of these people, including very young children.

Apologists for the Rangers, who were renamed the Paxton Boys when they marched on Philadelphia early the next year, claimed the frontiersmen reacted in self-defense against the indifference of Pennsylvania's pacifist leaders to the plight of frontier residents continually threatened by hostile Indians. But other observers said the Rangers knew the Conestogas were harmless and defenseless but massacred them in cold blood anyway because a search for vengeance, rather than justice, ruled their actions. These observers also said Lancaster's leaders allowed the violence to occur and then refused to identify and arrest the perpetrators.

No one was ever tried for obliterating the Conestoga tribe.

On the Road to *Glory*: Assault on Fort Wagner

On the afternoon of March 17, 1863, as Union and Confederate armies waited out the end of winter in Virginia and Tennessee, a large crowd of Columbians gathered at the railroad depot to cheer a group of men leaving for Harrisburg on their way to Boston. Eighteen men had volunteered for the Fifty-fourth Massachusetts Colored Infantry—one of the first black regiments in the Union army—the regiment whose story was told eloquently in the 1989 film *Glory*. These young men joined at least eight other black Lancaster Countians with the Fifty-fourth, most of whom struggled that summer in a vain attempt to capture Fort Wagner on Morris Island at the mouth of Charleston Bay. Another fourteen black Lancastrians spilled over into the Fifty-fifth Massachusetts Volunteers.

"We see no reason why Pennsylvania should not offer the same inducements to colored men," wrote Samuel Wright, editor of the *Columbia Spy*, several days after the eighteen men left town with a promise of $100 bounties at the end of service. "Those who have the grit to volunteer in the face of all the difficulties thrown in their way will make good soldiers and we can see no sufficient reason against employing them."

Wright admitted that the eighteen would be missed when the lumber season opened in the spring, when log rafts from northern Pennsylvania rushed down the Susquehanna and strong arms would be needed to haul them ashore. But the recruits were long gone from Columbia by then. And for some of them, that spring would be their last.

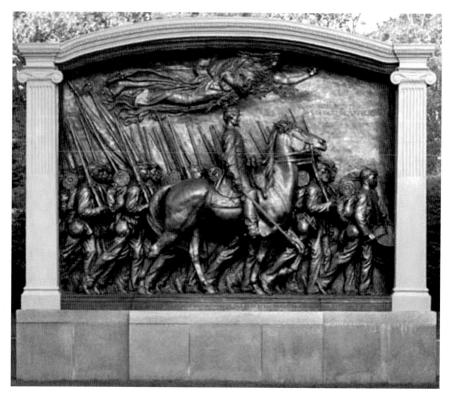

The Robert Gould Shaw Memorial on Boston Common depicts Shaw on horseback. His black troops, including Lancaster County men, march with him. *U.S. National Park Service.*

Leroy Hopkins, German professor at Millersville University and historian of black Lancaster, made a list of local blacks who fought in the Civil War. Besides the 40 who joined the Fifty-fourth and Fifty-fifth, Hopkins included another 160 names. These 200 men, including one of Hopkins's ancestors, served in twenty different "colored" units, most of them Pennsylvania volunteer regiments. Many who survived the war are buried at cemeteries in Lancaster, Columbia and Marietta. Others are interred on the battlefields where they fell.

Those who fought at Fort Wagner with Colonel Robert G. Shaw, the Fifty-fourth Regiment's commander, included William Edgerly, who had been among the eighteen Columbia volunteers. He and Samuel Ford, also of Lancaster County, died in the sand by the sea at the height of the battle on the evening of July 18, 1863. Of the regiment's six hundred black soldiers and twenty-two white officers who went into battle, more than 50 percent

were reported killed, wounded or missing. Shaw himself died and instantly became a martyr in the North.

Glory concludes with the attack on Fort Wagner and so does not examine the continuing distinguished record of the Fifty-fourth, as exemplified by Stephen A. Swails.

Born in Columbia, Swails enlisted at Elmira, New York. He fought at Fort Wagner and was cited for "coolness, bravery, and efficiency" in the Battle of Olustee, Florida, in February 1864. The regiment lost one hundred of five hundred men at Olustee and remained engaged along the coast until the end of the war. Swails had perhaps the most interesting career of any local man in the Fifty-fourth. He served as first sergeant of Company F at Fort Wagner and later was promoted to lieutenant. He was prominent in South Carolina's Reconstruction forces.

Hopkins said he believes that another of the Columbia eighteen may have been awarded the Congressional Medal of Honor. Among the seventeen blacks who received the medal for Civil War service is Samuel Pinn of the "Fifth Massachusetts." As there was no Fifth Massachusetts, Hopkins said that man probably was Walter Samuel Pinn of Columbia and the Fifty-fourth Massachusetts.

If *Glory* has a failing, said Hopkins, it is in presenting members of the Fifty-fourth as escaped slaves. Few were. None of the Columbians were runaways (although one, Elijah Berry, deserted the Fifty-fourth two months before Fort Wagner). "These were the sons of slaves who went to war," explained Hopkins. "They fought against a system that many of their parents had escaped."

On the Shaw Memorial in Boston are printed three tributes—one for the Fifty-fourth's white officers, one for the black troops and one for their joint achievements. The second tribute explains the military service of the men from Lancaster County who faced death on Morris Island in the summer of 1863:

> *The black rank and file volunteered when disaster clouded the union cause, served without pay for eighteen months till given that of white troops, faced threatened enslavement if captured, were brave in action, patient under heavy and dangerous labors, and cheerful amid hardships and privations.*

About 180,000 blacks served in blue uniforms—10 percent of the Union force. Abraham Lincoln credited them with tipping the balance in the North's favor.

BURNING THE SUSQUEHANNA BRIDGE AT COLUMBIA

In June 1863, the Confederacy's premier army headed for the heart of Pennsylvania. "If Harrisburg comes within your means, capture it," General Robert E. Lee told a subordinate general in the Army of Northern Virginia. General Darius N. Couch, commander of hastily gathered Union defenders in eastern Pennsylvania, acknowledged the probable Confederate objective when he said, "In no case must the enemy be allowed to cross the Susquehanna." Harrisburg was perhaps the most obvious potential target. Philadelphia was another. Lancaster County lay on the possible approach route to either.

As Confederate troops moved closer in late June, Lancastrians took action. Hundreds of local men joined Couch's sixteen-thousand-soldier force guarding the Susquehanna from the Juniata River's entry to the bridge at Conowingo. This ragtag army, headquartered at Harrisburg, included established militia, temporary recruits from three states, convalescing veterans, civilian volunteers from local towns and student companies from nearby colleges. Couch feared that five thousand of Lee's veterans could defeat this irregular force in a pitched battle.

Nevertheless, believing they would be safer behind Couch's lines on the east side of the Susquehanna, central Pennsylvania residents streamed across the river's major bridges to Harrisburg and Columbia with their personal effects and herds of livestock. This influx of frantic refugees added to residents' distress.

Couch ordered Colonel Jacob Frick, commander of the Twenty-seventh Pennsylvania Emergency Volunteers, to defend the bridge over the Susquehanna between Wrightsville, on the west shore, and Columbia. The world's longest covered span, extending more than a mile across the water, linked the two towns. Frick developed defensive works on the Columbia side of the river and extensive entrenchments in hills on the Wrightsville side. Then, concerned that his small force of twelve hundred would not be able to withstand a concerted Confederate attack, Frick made provisions to sabotage the bridge. He ordered his soldiers to bore holes in the bridge's first arch on the Wrightsville end. They filled the holes with gunpowder and attached fuses. If Frick's army buckled, the colonel would blow up the bridge's western end, preserving most of the span.

As advancing Confederate troops burned Thaddeus Stevens's ironworks at Caledonia, captured York, shelled Carlisle and threatened Harrisburg, additional thousands of panicked residents fled eastward across the river bridges, flooding Lancaster and Dauphin Counties.

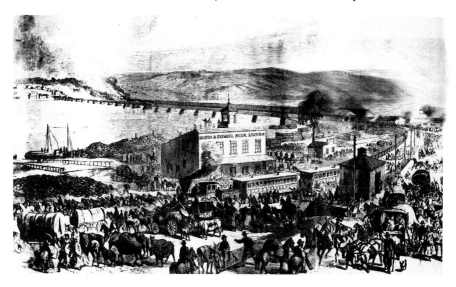

Union troops burned the Columbia Bridge on June 28, 1863, to prevent Confederate troops from crossing the Susquehanna River into Lancaster County. *Frank Leslie's Illustrated Newspaper.*

J.Q. Denney, who managed the Henry Clay Furnace between Columbia and Marietta, later remembered how he felt as General John Gordon's Confederate brigade left York and headed for Wrightsville, driving refugees in front of him. "I knew it would go hard with us if the Rebels crossed the river and got hold of a place like this, where we made pig iron for cannon casting later," he said. "They surely would destroy it, and I didn't know what might happen to my family." While most of the Denneys piled into a wagon and rolled east toward Chester County along roads clogged with other evacuating families, Denney remained behind to aid the Union cause.

On the afternoon of June 28, General Gordon moved his twenty-eight hundred troops into position near Wrightsville. He fired cannon shots over the town, unnerving both armed defenders and civilians. Then he attacked, wounding nine soldiers and capturing twenty before Frick ordered his unsteady forces to retreat. Union troops shoved coal-filled railroad cars in front of the bridge, behind which soldiers and townspeople crossed to the Columbia shore. Then Frick ordered engineers to explode the bridge's first arch. But that blast merely splintered the arch, barely shaking the full structure. As Gordon's troops marched into town, Frick frantically ordered his men to set fire to the span and to continue setting fires, using kerosene

as an accelerant, as they retreated. J.Q. Denney was among the fire starters, according to his great-grandson, the late John D. Denney.

Gordon's soldiers chased the defenders to the middle of the bridge, but flames, fanned by the wind, forced them back. The pine and oak span turned into an inferno on water, burning for five hours until it was entirely consumed.

Frick's soldiers and many Columbia residents lined the Susquehanna's east bank to watch the conflagration. Other area residents, panicked by the confusion of the day's events, kept moving toward Lancaster. "The retreat of the troops, the firing of the bridge, and the shell and shot falling into the river, created a panic [in Columbia]," reported the *Lancaster Examiner and Herald* on July 1, "and the skedaddle continued during the night as the shelling of the town was anticipated."

Gordon did not fire on Columbia; rather, he helped Wrightsville residents put out fires that had spread to a lumberyard and adjoining houses. Then he turned around and marched to confront the Union Army of the Potomac at Gettysburg. General Lee ordered other elements of his army, repulsed in skirmishes with Union defenders on the Susquehanna's West Shore at Harrisburg, to move toward Gettysburg as well. The crisis at the Susquehanna was over.

The defenders of the bridges and the citizens of the towns along the river did not know that. On the afternoon of July 3, when they heard rumbling from the terrific cannonade preceding Pickett's Charge, they worried that Confederates could win at Gettysburg and Lee's army could head east again.

It did not happen that way, and so Lancastrians dodged the big one.

A LANCASTRIAN RAISED THE USS *MAINE*

Amidst a small grouping of monuments in Buchanan Park in Lancaster's West End stands one of the county's most impressive war memorials. A rifle-toting soldier flanked by two cannons, it commemorates the Spanish-American War of 1898. Its informational plaques were cast from metal recovered from the USS *Maine*. The U.S. Army Corps of Engineers took that metal from the *Maine* after isolating the ship from the waters of Havana Harbor following the explosion of February 15, 1898. It distributed hundreds of parts of the ship and bones from its 229 dead sailors around the United States.

Lancaster has another connection with the *Maine*. General William Murray Black, the Corps of Engineers officer in charge of raising the *Maine*

The Spanish-American War monument in Lancaster's Buchanan Park. *Photo by Jack Brubaker.*

from Havana Harbor, was born here. Black grew up in the 323 North Duke Street building that now houses the Iris Club. He graduated from Lancaster High School and spent nearly three years at Franklin & Marshall College before receiving an appointment to West Point Military Academy, from which he graduated in 1877 at age twenty-two.

Biographical information provided by the Corps of Engineers proves that Black had a distinguished and busy career, specializing in river and harbor work and port development. He commanded the first landing of U.S. forces in Puerto Rico during the Spanish-American conflict and served as chief engineer of Cuba. He was appointed army chief of engineers in 1916 and directed that department throughout World War I, rising to the rank of major general. Black was the first president of the Society of American Military Engineers. He died in 1933 and was buried at West Point.

Although the *Maine* probably exploded accidentally, America was ready for conflict. U.S. patriots put the blame on Spain and fought "a splendid little war" that quickly overwhelmed the enemy. "Remember the *Maine*" was the war cry in 1898, but a few years later everyone in Havana Harbor wanted to forget the ship. Its decaying hulk protruded above water, attracting an interest that Cubans and Americans preferred not to cultivate in perpetuity.

Congress authorized the Corps of Engineers to dispose of the vessel in March 1910. Black and his crew moved into Havana's Plaza Hotel for the duration. Theirs was not a simple task. The engineers built a huge cofferdam all the way around the ship and pumped out the water inside. Then they made the *Maine*'s remains seaworthy so that a tugboat could haul the ship into international waters and sink it properly. By the summer of 1911, the cofferdam had been built and the water pumped out.

Before the ship was towed to sea, naval officers allowed survivors and families of deceased crewmen, cities and war veteran groups to apply for relics. They were bombarded with requests. Some relics went to the Naval Academy at Annapolis. The ship's mainmast is at Arlington National Cemetery. Sheldon, North Dakota, has a six-inch shell.

The informational plaque on the monument's front was made from metal recovered from the USS *Maine*, sunk in Havana Harbor in 1898. *Photo by Jack Brubaker.*

The General Wm. S. McCaskey Camp, United Spanish War Veterans of Lancaster, erected the Buchanan Park monument in 1913 to the memory of Lancaster's veterans. The memorial stands in a grove of evergreens well back from Buchanan Avenue. The front and rear information plaques forged from *Maine* metal say that a powder tank from the ship also was included in the monument. It is not there now. No one knows what happened to it. The War Department donated the cannons and cannonballs. The cannonballs also are missing.

In March 1912, after Lancaster's veterans and anybody else who wanted a piece of the *Maine* had been satisfied, General Black and his engineers opened the cofferdam in Havana Harbor, cabled the old wreck to a tugboat and hauled it out into the Gulf of Mexico. Past the three-mile limit, the engineers finally let the USS *Maine* sink out of sight in the sea.

WORRYING ABOUT SABOTEURS IN WORLD WAR II

When the Japanese bombed Pearl Harbor, the explosions reverberated throughout thousands of American communities that had been preparing for war while praying to avoid it. The sneak attack on December 7, 1941, accelerated the urgency of those preparations and prayers. Americans had been targeted by a foreign enemy on U.S. soil for the first time since the War of 1812. The possibilities of assault by air and sea had progressed enormously since World War I. For the first time in the twentieth century, Lancastrians felt vulnerable at home

More than a year before Pearl Harbor, as the war expanded in Europe, volunteers in the Lancaster Defense Council had begun scanning the skies for enemy planes. Volunteer guards had been patrolling hydroelectric facilities at Safe Harbor and Holtwood on the Susquehanna.

After December 7, additional recruits reinforced these and other advance teams, and Lancaster's leaders created new defense programs. As scores of Lancastrians rushed to enlist in the armed forces, the Pennsylvania Home Guard posted armed men at highway and railroad bridges over the Susquehanna. The Emergency Auxiliary Police Force added guards at industrial plants and utilities. The army took over Lancaster Municipal Airport, flew in military planes and grounded civilian aircraft. The county established an Air Raid Precaution Service to operate twenty-seven aircraft-spotting stations and made provisions for blackouts in case the enemy arrived at night.

Lancastrians expected an assault at any time. Two days after the attack on Pearl Harbor, rumors of air raids over New York and California, which proved to be false, caused Mayor Dale Cary to proclaim a state of emergency in Lancaster City.

Much of the U.S. military was caught relatively unprepared for the enormous challenges of World War II. All branches of the service required extraordinary amounts of supplies to wage war on several continents. Lancaster industries converted to war production as quickly as they could. On a large scale, Armstrong Cork Company produced shell casings, bomb racks, incendiary bomb casings and aircraft fuselage parts. On a smaller scale, the Pequea Works, a fishing tackle factory, produced fishing kits for aviation and naval life rafts.

Individuals threw themselves into the war effort, purchasing U.S. bonds to cover war expenses, assembling scrap metal to be recycled into armaments (the Salvage and Conservation Committee collected an average of one hundred pounds of metal per Lancastrian in 1943) and rationing gasoline, tires and food. Children participated in many of these activities and, as children will, turned their work into play. One rationing song went like this:

> *I like sugar and things that are sweet,*
> *and here in this country there's plenty to eat,*
> *but Uncle Sam says, "Take care,*
> *don't waste any food that we all must share."*

Meanwhile, war news and obituaries dominated the front page of every day's newspaper. More than 17,000 Lancastrians served in uniform, and 553 died, so the war in some way affected most families in the county.

Uniformed soldiers and sailors on leave from posts elsewhere walked the streets of Lancaster and Columbia. Naval aviation cadets trained regularly at Franklin & Marshall College. The army operated a camp for about fifty or sixty soldiers on the site of a former Civilian Conservation Corps camp in what is now Conestoga Pines Park east of the city. Their exclusive assignment was to guard the Pennsylvania Railroad Bridge over the Conestoga River.

All of these soldiers, industrial guards and plane spotters were not engaging in an exercise in mass paranoia. German U-boats were sinking American ships just off the Atlantic Coast. German saboteurs had landed in New York and Florida. (They were quickly caught and executed.) Lancastrians feared sabotage by the Japanese as well as Germans. Shortly after Pearl Harbor, authorities seized two Japanese scientists employed by a county poultry

hatchery. The Pennsylvania Railroad gave orders to the local train station: do not issue tickets to anyone of Japanese ancestry.

Fear led to a national civil liberties catastrophe. Thousands of Japanese-, German- and Italian-Americans were imprisoned, many for the duration of the war. (Recognizing its error, the United States has since compensated

Lancastrians gathered in Penn Square on August 14, 1945, to celebrate V-J Day and the end of World War II. *Lancaster Newspapers.*

the Japanese and recognized the Italians. Imprisoned German-Americans, including the late Joe Feilmeier, of Millersville, never received recognition.)

Some people look back and say that Americans overreacted to the potential danger at home during World War II. Considering that the enemy was committed to waging total war worldwide, however, preparing for an attack seemed the responsible course. Combatants in World War II made little distinction between military and civilian personnel. Both sides deliberately killed noncombatants, including children, as distinctions established under international law were buried beneath millions of bodies of innocents.

In *The Skin of Our Teeth*, Thornton Wilder's apocalyptic comedy first staged the year after Pearl Harbor, Sabina the maid says, "The whole world's at sixes and sevens, and why the house hasn't fallen down about our ears long ago is a miracle to me." Many Lancastrians felt that way during an ordeal that concluded abruptly in the summer of 1945, when the United States introduced the atomic age to Japanese civilians who never knew what hit them.

INFLUENTIAL LANCASTRIANS

DECLARATION SIGNER WAS A RELUCTANT REBEL

George Ross, the only Lancastrian to sign the Declaration of Independence, penned his name with bold strokes and then underlined it. That he signed the document at all, let alone with emphasis, surely surprised some people.

Born in New Castle, Delaware, in 1730 and educated in Philadelphia, Ross moved to Lancaster in 1751 to begin practicing law. In 1768, Lancastrians made him a delegate to the Pennsylvania Assembly. He performed admirably and impressed all the right people. In 1775, the assembly named Ross a delegate to the First Continental Congress, but by the end of that year Lancaster's revolutionary firebrands decided that Ross and other county representatives to the assembly were insufficiently radical and unseated them all. Lancastrians were not the only ones who questioned Ross's allegiance to the cause. John Adams, who would sign the Declaration and become president of the United States, called Ross "a great Tory."

While Ross was reluctant to rebel against the Crown, he increasingly sympathized with independence as conflict with Great Britain continued. He eventually lost the "Tory" label. During his exile from state and national office, Ross was appointed to the twenty-five-member Committee of Safety, an organization that ran the state's military effort; his task was to inspect military stores. He also served on several countywide revolutionary committees and organized a company of militia. Ross persuaded the

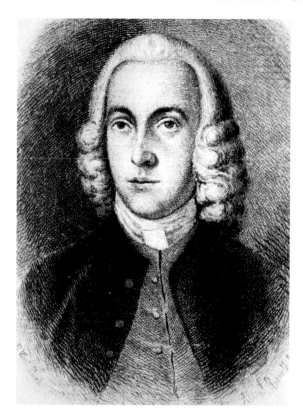

George Ross, signer of the
Declaration of Independence.
Lancaster Newspapers.

firebrands of his faithfulness to the cause, was restored to the assembly and began representing Pennsylvania in the Second Continental Congress on July 20, 1776.

So how did a man who was not reseated until sixteen days after the Fourth of July get to sign his name to the Declaration?

Actually, only John Hancock, president of the Congress, and Charles Thompson, its secretary, signed the document in early July. All the rest of the members but three signed on August 2. Ross had been reseated for nearly two weeks by then.

In addition to his work with the Continental Congress, Ross served as vice-president of the Pennsylvania Constitutional Convention of 1776. Both conventions, conveniently for dual delegates, met in Philadelphia. At the state convention, according to historian Jerome Wood, Ross "on account of President Benjamin Franklin's intermittent illnesses…reportedly handled 'the whole business of the department,' including some of the thinking which Franklin 'declined the trouble of doing.'"

Ross was appointed a judge of the court of admiralty for Pennsylvania in 1779. Within a few months, he died from a violent attack of gout at his temporary residence in Philadelphia. The Patriot was forty-nine years old.

An interesting story, possibly true, associates George Ross with the first American flag. He reportedly recommended Betsy Ross to George Washington and Robert Morris for the job of making the nation's first emblem. Betsy was George Ross's niece by marriage.

Ross was one of several leading Lancastrians who kept slaves during a Revolution led by free white men for the benefit of free white men. He owned three slaves.

Franklin & Marshall College owns handsome portraits of George Ross and his wife. The Philadelphia artist Benjamin West painted the couple in 1755 when he was seventeen years old and Ross was twenty-five.

Ross lived in a home on East King Street, near Duke Street, where the old Lancaster County Courthouse now stands.

A monument to Ross marks the site of his summer home at 320 East Ross Street. Ross Street and Ross Elementary in the School District of Lancaster are named for him. That area of the city and southern Manheim Township is known as Rossmere.

Ross is buried in the yard of Christ Church in Philadelphia along with many other Patriots, including Ben Franklin.

Frederick Muhlenberg, First House Speaker

After he was named the first Speaker of the House of Representatives in 1788, Frederick Augustus Conrad Muhlenberg confided to Dr. Benjamin Rush that he would have liked a smaller salary. Because he earned twice as much as other congressmen, Muhlenberg felt "under the Necessity of keeping up that Form & parade which is now in some Measure expected & which I ever had a natural Aversion to."

The standard salary in the first federal Congress of the United States was six dollars a day. Muhlenberg received twelve dollars.

Beyond the quaintness of his salary ethics, there's a purely parochial reason for Lancastrians to consider the life of Frederick Muhlenberg. A case can be made for the Speaker being Lancaster County's representative in that first Congress under the new Constitution.

Son of Henry Melchior Muhlenberg, founder of the Lutheran Church in America, Frederick (1750–1801) was one of eight at-large delegates

Portrait of Frederick Muhlenberg by Joseph Wright. *Courtesy National Portrait Gallery, Smithsonian Institution.*

who represented Pennsylvania before Congress drew electoral districts. He was very much an at-large Pennsylvanian, having served as Speaker of the Pennsylvania Assembly and presiding officer at his state's constitutional ratifying convention. But he also had spent a great deal of time specifically in Lancaster, serving local Lutheran congregations as pastor in Brickerville and Manheim before the Revolutionary War and living in Schaefferstown, which was then part of the county. Late in his life he returned to Lancaster, where several members of his prominent family lived. He died here. Perhaps most significant, Muhlenberg was not only a Pennsylvania political leader but also, more specifically, the leader of the state's German community. Lancaster was the center of that community.

This view that Muhlenberg may have tended to represent Lancastrians foremost in the first Congress was established by the late U.S. Representative Edwin D. Eshleman and former Representative Robert S. Walker in their book, *Congress: The Pennsylvania Dutch Representatives, 1774–1974.* On the other hand, most references to members of the first federal Congress don't mention Muhlenberg's Lancaster connections. Take your choice.

Muhlenberg served four terms. He was Speaker during his first and third terms. He ruined his political career in the mid-1790s when he cast the deciding vote for the Jay Treaty with England.

The Philadelphia artist Joseph Wright painted Muhlenberg in 1790 with his quill firmly in hand, bills ready for signing, sitting in the Speaker's chair in Federal Hall when the U.S. capital was still in New York City. It is the only contemporary depiction of the interior of the House chamber in Federal Hall.

Muhlenberg's chair was extra wide—"to hold two, I suppose," said Vice President John Adams. Muhlenberg needed the larger chair, according to a contemporary magazine report:

> [The Speaker] *by his portly person and handsome rotundity, literally filled the chair. His rubicund complexion and oval face, hair full powdered, tambored satin vest of ample dimensions, dark blue coat with gilt buttons, and sonorous voice…all corresponding in appearance and sound with his magnificent name.*

All that for twelve dollars a day.

WHEN JAMES BUCHANAN WAS TOSSED OUT OF COLLEGE

President James Buchanan, Pennsylvania's only president and the only bachelor to gain that high office, also was the only president to get kicked out of college.

Before Buchanan settled in Lancaster, he left the security of his family at Mercersburg and matriculated as a junior at Dickinson College in Carlisle. In September 1807, Buchanan was sixteen years old and the college was thirty-four. "Drunkenness, swearing, lewdness & dueling seemed to court the day," said then-President Jeremiah Atwater of the atmosphere in Carlisle. The students were "indulging in the dissipation of the town, none of them living in the college." It was folly, he said, "to expect that a college could flourish without a different state of things in the town [and] I hope that as God has visited other states, he will yet visit Pennsylvania."

President Atwater obviously had low expectations for townies and students. Young James Buchanan met those expectations.

Buchanan was one of forty-two students. The school had three professors and one building, the elegant limestone West College, designed by Benjamin Latrobe. The college, Buchanan later claimed, was "in wretched condition."

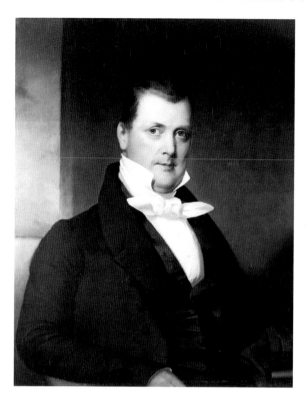

Portrait of James Buchanan, as he appeared about age forty, by Lancastrian Jacob Eichholtz. *Lancaster Newspapers.*

Buchanan at first studied diligently, but he found the other students liked him better if he did not. So "without much natural tendency to become dissipated," he said, "and chiefly from the example of others, and in order to be considered a clever and spirited youth, I engaged in every sort of extravagance and mischief." Our future fifteenth president liked his liquor. On one occasion, he quaffed sixteen regular toasts before settling into some serious drinking. He also smoked cigars, which was against the rule of the day. And, because he was very bright, he exhibited a conceit that infuriated the faculty.

Despite his waywardness, Buchanan concluded his junior year with excellent grades and returned to Mercersburg in the autumn of 1808 to enjoy vacation before his senior term. One September afternoon, his father received a message from President Atwater. The president, who deplored dissipation, had expelled young Buchanan for disorderly conduct.

This information greatly disturbed the future president. But his fledgling political instinct blossomed, and he contacted a friend, Dr. John King, who just happened to be the new president of Dickinson's board of trustees. After

giving Buchanan a brief lecture, King quickly persuaded Atwater to reinstate the prodigal. The speed with which Buchanan was readmitted suggests that either King was far more forgiving than Atwater or the expulsion may have been designed primarily to teach Buchanan a lesson.

During his senior year, Buchanan went right on drinking—perhaps more discreetly—and remained as conceited as ever, according to his contemporaries. By all accounts, he deserved highest honors at the college, and his fellow students would have conferred them upon him; but the faculty chose otherwise, embittering Buchanan toward the school for the rest of his life.

When he graduated in 1809, Buchanan happily left Dickinson behind. He later said that he departed Carlisle "feeling but little attachment toward the Alma Mater." He settled in Lancaster to practice law and did not think much more about Dickinson or Carlisle. In 1853, Buchanan became president of the board of trustees of the merged colleges of Franklin and Marshall in Lancaster. Thereafter, he gave more of his time and money to F&M than to Dickinson.

Three years later, he was elected president of the United States. He presided over one of the worst administrations in the nation's history, which may not have surprised President Atwater and the Dickinson faculty.

Nurses Honor Generosity of a Grieving Mother

On Edgar Allan Poe's birthday each January 19—from 1949 to 2009—someone walked from the shadows of Westminister Burying Ground in downtown Baltimore and placed roses and cognac on the poet's grave.

On the afternoon of Harriet Lane Johnston's birthday each May 9, nurses from Johns Hopkins Hospital honor her memory with a floral bouquet at her grave site. An elaborate cross marks the final resting place of President James Buchanan's niece in Greenmount Cemetery, not far from Poe's marble obelisk in Westminister. The nurses began their tradition many years before the poet's benefactor started his. They have been carrying flowers to Harriet Lane since 1913. "It warms my heart," said Polly Hesterberg, an administrator at the Children's Center of Johns Hopkins Hospital. "I have such admiration for Harriet Lane. She was so insightful to establish special care for children and that Hopkins would be the place to do it."

To explain why nurses carry flowers to a grave site several blocks from Johns Hopkins will take a little doing. The story involves an aspect of Harriet Lane's life that may be unfamiliar to many readers.

Harriet Lane Johnston, niece of President James Buchanan. *Lancaster Newspapers.*

Born at Mercersburg in 1830, Harriet was orphaned as a young girl and raised by her uncle at Wheatland, his Lancaster home. When James Buchanan became president in 1856, Harriet moved into the White House and functioned as first lady. Harriet returned with Buchanan to Wheatland four years later. She continued playing hostess until 1867, when she married Henry Elliott Johnston of Baltimore. The couple resided in that city and had two sons. In 1881, James Buchanan Johnston died at age fourteen. His younger brother, Henry, died the following year. He was only twelve. Both boys succumbed to what was believed to be rheumatic fever. In 1884, Henry Elliott Johnston died of pneumonia.

Harriet Lane was fifty-four years old, and her immediate family was gone. For the rest of her life, she wore black.

She did not, however, live less fully. She worked hard to counteract the increasingly negative image of the Buchanan presidency. She moved to Washington and started a school for boys that became St. Albans. She established the core collection of the Smithsonian Institution's National

Gallery of Art. And she contributed the funds that built the Harriet Lane Home for Invalid Children, now the Harriet Lane Pediatric Primary Care Clinic and other facilities of the Children's Center at Johns Hopkins Hospital.

After the Johnston boys fell ill, their parents discovered that Baltimore did not have a hospital to care for children with chronic diseases. They incorporated the Home for Invalid Children the year before Johnston died. He insisted that it be named for Harriet. The facility finally opened in 1912, nine years after Harriet's death, as the first pediatrics unit in the United States. Research at the hospital has helped eliminate scarlet fever and measles. The Harriet Lane Handbook has served as a pediatricians' bible.

Harriet Lane was buried at Greenmount Cemetery beside her husband and sons. In her will, she stipulated that nurses from the Harriet Lane Home place flowers on her grave each year on her birthday, a practice that began the year after the home was completed.

"As the years pass, fewer and fewer people actually go to these old cemeteries," said Hesterberg, "so in this way it keeps someone looking over her grave site and making sure that it's well."

It is also appropriate that this birthday tradition, honoring a mother whose love for her sons prompted creation of a famous pediatrics hospital, precedes so closely the day on which we honor all mothers.

LANCASTRIAN FAILED TO DELIVER FIRST MAIL BY AIR

John Wise, a Lancaster County native and pioneering aeronaut, attempted to deliver the nation's first airmail in 1859—by hot-air balloon.

On his first try, he failed spectacularly, crashing his balloon in New York and destroying all the mail. The second time he failed in more mundane fashion, floating the wrong direction in Indiana and causing the mail to arrive at its destination weeks late. Only one piece of mail is known to have survived the second effort. Held today in the collections of the Smithsonian National Postal Museum in Washington, the surviving letter was sent to W.H. Munn of New York City.

On August 17, 1859, Wise set off from Lafayette, Indiana, in a balloon named *Jupiter* with the intention of delivering Munn's letter and others to New York City. But in August the air was still, and Wise had to ascend to fourteen thousand feet before locating a breeze. That breeze blew him south instead of east. He descended five hours and thirty miles later in Crawfordsville, a town in the same county as Lafayette. Wise put the mail

on an eastbound train. The *Lafayette* [Indiana] *Daily Courier* termed Wise's abbreviated, wrong-way flight "trans-county-nental."

During his long life, Wise was no stranger to wrong-way flights, although he was more often on target than not.

John Wise was born in Lancaster on February 24, 1808. At age fourteen, he read about a balloon trip in Italy and decided to go aloft himself. In an initial, unmanned experiment, he tied together four inflated ox bladders. Then he attached a cat and tossed bladders and cat from an upper-story window. The fall was precipitous. The cat survived. The bladders did not.

Wise made his first ascent by himself in Philadelphia in the spring of 1835. He went up several thousand feet and remained there for over an hour, landing safely near Haddonfield, New Jersey. He flew several more flights from other cities before making his first Lancaster ascent on October 1, 1835. That trip ended in disaster. The balloon lurched into a house. Wise escaped to the roof, watching his balloon disappear eastward. Eventually it exploded, with remnants descending on Bordentown, New

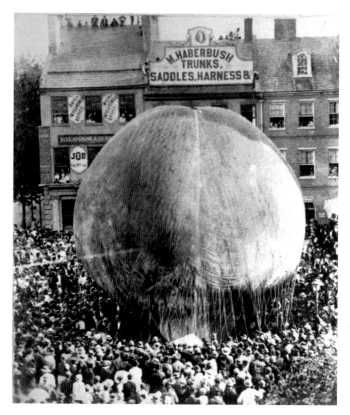

John Wise
preparing to
ascend in a balloon
from a crowded
Centre Square in
the early 1870s.
Lancaster Newspapers.

78

Jersey. But Wise continued making flights here and elsewhere, launching his balloons several times in the midst of huge crowds in Lancaster's Centre Square.

During the Civil War, Wise persuaded the U.S. War Department to let him work for the army. During some of the initial campaigns, he provided assistance in tracking enemy forces. But that job ended badly when telegraph wires cut his balloon's tethers. Wise instructed Yankee soldiers to shoot holes in the balloon to keep it from falling into enemy hands.

The balloonist continued flying into his seventies. In the early autumn of 1879, he and James Downey, also of Lancaster, set off from Lindell Park, St. Louis, with George Burr, a local bank teller, as a passenger. Burr paid sixty dollars to take his first and last balloon ride. Observers saw the trio sail over Lake Michigan, and that was the end of balloon and passengers.

It's hard to know who kept count, but Wise supposedly ascended in balloons more than 250 times before his fateful final journey.

THREE THOUSAND PACKED CEMETERY TO HONOR FALLEN SOLDIER

Of the numerous veterans buried in Lancaster Cemetery, including 207 Union soldiers in the GAR plot alone, 3 are Civil War generals, and several others attained substantial rank during the Civil War and other armed conflicts. Among these veterans' graves is a large stone marking the Van Camp family plot, wherein is buried Lieutenant Cornelius Van Camp.

Van Camp died suddenly in October 1858 when a Comanche Indian fired an arrow through his heart. He was twenty-five years old. The next March, he was buried at Lancaster Cemetery.

Van Camp's grave marker is popular with cemetery tours. "Kids love the story about being shot in the heart," observed William Stahler, a former cemetery superintendent.

The young lieutenant with the abbreviated life was born in Lancaster in 1833. He graduated from the military academy at West Point in 1855. He was appointed second lieutenant in the Second Cavalry Regiment and served with distinction as topographical officer and adjutant. In the autumn of 1858, Van Camp's regiment, under the command of a Major Van Dorn, traveled from Texas into the Wichita Mountains of the Indian Territory (now Oklahoma). The regiment encountered a band of hostile Comanches and charged them. Van Camp was one of the first to enter the Indian camp and

The tombstone of Lieutenant Cornelius Van Camp in Lancaster Cemetery explains that he was "shot through the heart while gallantly charging the enemy." *Photo by Jack Brubaker.*

was first killed. Van Dorn was wounded. The regiment routed the Indians, who left several dozen of their warriors on the battlefield.

Van Camp was buried near the place where he fell. Four months later, his body was exhumed and sent to Lancaster. That journey took another month. Van Camp's body arrived in the middle of March 1859. The body rested at the home of Van Camp's parents, John C. Van Camp and Mary Bowen Van Camp, who lived on the southwest corner of Centre Square. The Van Camps were a locally prominent family, and Lancaster newspapers reported the arrival of their son's remains in detail.

The Fencibles, a military unit that would be active in the Civil War, accompanied Van Camp's body to the armory, located on the second floor of Fulton Hall (now the Fulton Opera House). There the body lay in state. So many Lancastrians came to the viewing that some were turned away at day's end. The funeral took place at 3:00 p.m. on March 16. The Fencibles and other military companies and veterans, city officials, Franklin College students and members of the Van Camp family formed a procession accompanying the hearse to Lancaster Cemetery. There the Reverend Walter Powell, pastor of First Presbyterian Church, discussed the brief career of the deceased and exhorted mourners to be prepared to meet

sudden death themselves. The Fencibles fired three salutes. Lancaster's *Daily Evening Express* reported that more than three thousand people crowded into the cemetery during funeral proceedings.

"I remember that funeral very well, although I was only 12 years old," recalled Lancastrian Washington T. Hambright in a 1931 interview with the *Lancaster New Era*. "Those were exciting times, with Civil War gathering on the horizon, and the funeral of a popular young Lancaster man, a West Pointer, who had been killed in battle with the Indians in the far west naturally caused great excitement."

Some readers may be wondering about those three generals buried at Lancaster Cemetery.

Major General John Fulton Reynolds commanded the First Corps of the Army of the Potomac. He was shot dead on the first day of the Battle of Gettysburg in the summer of 1863. He is generally recognized as one of the most effective officers on either side of the conflict.

Colonel Henry A. Hambright commanded the Lancaster-based Seventy-ninth Pennsylvania Volunteer Infantry during many battles in the Civil War's western theater. He was brevetted brigadier general near the end of the war and retired from the regular army as a major of infantry in 1879.

Colonel Samuel Ross served with the regular army in the Florida Indian wars, in Mexico and during the Civil War. He was brevetted brigadier general on April 13, 1865, four days after Robert E. Lee surrendered. He retired from the regular army as a colonel in 1875 and drowned five years later.

GENERAL FROM MANHEIM PROVED GRIT AT BULL RUN

General Samuel Peter Heintzelman, whose home on Manheim's Main Street is passed by thousands of vehicles a day and invaded by thousands of pairs of trousers each year, is a war hero whose image does not quite register with many Lancastrians.

The only local soldier known to have been wounded at First Bull Run, Heintzelman, at fifty-seven, was the oldest general on the field at Second Bull Run. Although he did not distinguish himself in either fight, he was cited for exceptional service at Williamsburg on the Virginia Peninsula. A career officer who commanded in Texas after the Civil War, Heintzelman was faintly praised by the *Manheim Sentinel* upon his last visit home in 1878:

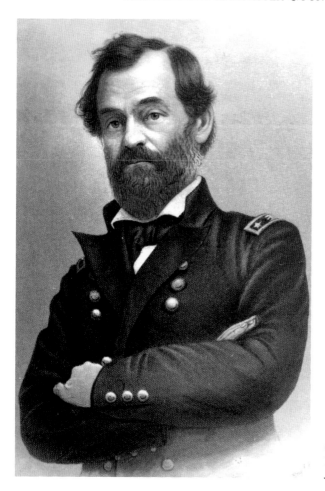

General Samuel Peter Heintzelman. *Lancaster Newspapers.*

"The General has done good service for his country in years gone by, and carries his advanced age exceedingly well." A contemporary of Heintzelman said, "He somehow just missed being an effective corps commander."

This Pennsylvania Dutch patriot probably deserves better.

Born in a newly built brick store/house (now a dry cleaning establishment) at 22 South Main Street in 1805, Heintzelman grew up in a leading Manheim family. Congressman James Buchanan recommended him to West Point Military Academy in 1822. From his graduation until the Mexican War, Heintzelman performed routine military service. He was brevetted major at Huamantla and later promoted to lieutenant colonel for service in the Southwest.

During the Civil War, Heintzelman performed as well as could be expected under a series of mediocre Union commanders. In his book, *Battle at Bull*

Run, William C. Davis described Heintzelman: "Physically he was anything but impressive. Slightly paunchy, with a scraggly graying beard and thinning hair, he looked more like a bemused farmer than a daring commander. Yet there was grit in the man."

It took courage for Heintzelman to get through First Bull Run on July 21, 1861. In charge of a division of General Irwin McDowell's army, Heintzelman captured Henry House Hill, the commanding position on the battlefield twenty-six miles southwest of Washington. But Confederate troops drove Heintzelman and all other Yankee forces from the field and back toward Washington before the day ended. In the process, the Rebels wounded the general in his right arm. Heintzelman refused to leave his troops. He would not even dismount while a surgeon cut the bullet from his crippled arm and dressed the wound.

Today, there are few signs on the battlefield that Heintzelman was ever there. There's nothing on Henry House Hill, which is dominated by the Henry House and Stonewall Jackson's equestrian statue. Several Park Service plaques elsewhere on the field do mention movements of the troops in Heintzelman's command.

After recovering from his wound, Heintzelman commanded the Third Corps in the Peninsular Campaign, where he was cited for "gallant and meritorious service," and at Second Bull Run. That was his last battle as a field commander. He spent much of the rest of the war in command of portions of Washington's defenses. After retiring from the army in 1869 as a major general, a substantial accomplishment at a time when regular army generals were few, he went into business in New York City and then moved to Washington. He died in 1880, at age seventy-four, and is buried at Buffalo, New York, his wife's home.

His own large childhood home, marked by a Pennsylvania Historical and Museum Commission plaque in 1962, stands just off the central crossroads at Manheim. Heintzelman would barely recognize it today. The front is still mostly brick, broken up by contemporary windows, but the rest has been stuccoed and the whole building extended to the rear by Shaub's Dry Cleaning. Shaub's, various offices and apartments have altered much of the interior. An oval-shaped central staircase is an impressive remnant of what must have been a handsome house in 1805 Manheim. A Shaub's employee said that few people ask for historical information on Heintzelman or the house.

Sam Heintzelman's name never quite became famous, and his home never became a tourist attraction.

THADDEUS STEVENS DIRECTED
JOHNSON'S IMPEACHMENT

Unfortunate man! thus surrounded, hampered, tangled in the meshes of his own wickedness— unfortunate, unhappy man, behold your doom!

Thus did Thaddeus Stevens, in a speech to the House of Representatives in March 1868, describe what he believed would be the fate of President Andrew Johnson. The House had just impeached the president, and Stevens was certain the Senate would convict him.

Lancaster's representative was wrong, but not by far.

Andrew Johnson and Thaddeus Stevens despised each other. That animosity helped forge the presidential crisis of 1867–68. Neither man would relent, and the result ruined what was left of Johnson's presidency and forever damaged Stevens's reputation. Leader of Radical Republicans in the House, Stevens believed that the rules of Reconstruction should be used as a tool to beat the defeated white South into subjugation and to protect newly legislated black rights. Johnson, a Southern Democrat,

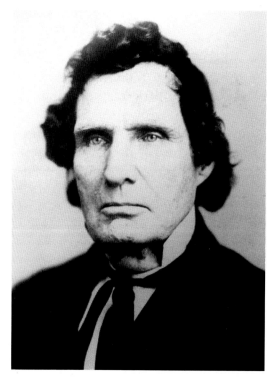

U.S. Representative Thaddeus Stevens. *Lancaster Newspapers.*

antagonized Stevens by vetoing initiatives of the Republican congressional majority. Stevens transferred his hatred for the Confederacy and the South to Johnson and his policies. Johnson called Stevens a traitor. He also feared him as a volcanic "flow of living passion."

Stevens was not involved in the earliest impeachment efforts during the winter of 1867. These investigations by the House Judiciary Committee included Johnson's private life and led to two failed votes to impeach.

The larger crisis came near the end of 1867, when Johnson dismissed Secretary of War Edwin Stanton, a strict adherent of the principles of Reconstruction, without consulting Congress. The Radical Republicans quickly restarted impeachment efforts, with Stevens's Committee on Reconstruction leading the way. Stevens relentlessly pressed the issue all winter, contending that Johnson not only should be removed from office but also fined and imprisoned "like a common criminal." In February 1868, the full House impeached the president on a largely party-line vote of 126 to 47. Stevens formally announced this indictment to the U.S. Senate, which would try Johnson.

An argument erupted over whether a president could be removed for simply thwarting the will of the majority party, as opposed to committing "high crimes and misdemeanors." Stevens and the Radicals believed Johnson's attempts to obstruct Republican policies were reason enough to dismiss him. House Republicans drew up ten articles of impeachment, most related to the Stanton affair. Stevens believed these were not sufficient to win the Senate trial and created an eleventh, an omnibus article. It was by far the strongest. Stevens and six other House members served as impeachment managers, or prosecutors, during the trial. Because of Stevens's declining health, Ben Butler, a former Civil War general, nominally led these managers. But the Lancastrian supplied the prosecution's brains.

Stevens was dying of a variety of ailments. Modern analyses suggest these may have been heart trouble or possibly kidney or prostate problems. He also may have suffered from stomach cancer. He was so emaciated that he had to be assisted from place to place. Sometimes fellow representatives carried him in his chair.

The Radical Republicans approached the trial as a political, rather than legal, proceeding. The nation's press, for the most part, did the same. The process often turned nastily partisan. Stevens made the ablest summary argument against Johnson. As he spoke in a weak voice, he fortified himself by sipping a mixture of brandy and raw eggs. His reasoned indictment slipped into anger near the end. He attacked Johnson as that "wretched

man, standing at bay, surrounded by a cordon of living men, each with the axe of the executioner uplifted for his just punishment."

The Senate voted thirty-five to nineteen against Johnson, missing the two-thirds majority needed to oust the president by one vote.

"The country is going to the devil!" lamented Stevens.

Obsessed with the near miss, Stevens drafted new articles of impeachment. The House rejected them. "It is lamentable," said the *New York Herald*, "to see this old man, with one foot in the grave, pursuing the President with such vindictiveness." On July 7, Stevens finally quit. "I have come to the fixed conclusion," he said, "that neither in Europe or America will the Chief Executive of a nation be again removed by peaceful means."

Five weeks later, the bitter old man died.

ARTIST CAROLINE PEART LIES IN OBSCURE CEMETERY

It is a very solid place.

A formidable brick wall encloses a compact cemetery lying between the downriver edge of Washington Boro's residential area and vast fields underlain by Susquehannock Indian artifacts. The Herr family established this burial ground in 1800. Martha Herr Peart erected the wall in 1904 in memory of her parents. The cemetery is filled with tombstones memorializing Herrs and Hoffmans, Stamans and Stoners— people whose descendants live in the area today. The largest of the stones, a vertical slab, is inscribed with the names of Martha Herr Peart, her husband, John, and her daughter, Caroline.

Caroline Peart was one of Lancaster County's most exceptional artists. She is buried at one of the county's most unusual cemeteries.

"She was an amazing woman," said Carol Faill, former director of the Phillips Museum of Art at Franklin & Marshall College. "The fact that she was able to do what she did as a woman at that time is extraordinary."

Peart was born in Columbia in 1870. She studied in Italy, France and Spain and lived and painted in Philadelphia from 1905 to 1920. She completed many of her paintings, mostly portraits and landscapes, between 1890 and 1910. Following the death of her father, divorce from her husband (the art critic Christian Brinton) and the relocation of her mentor (artist Cecilia Beaux), Peart lost heart in her art. She and her widowed mother moved to Washington Boro in 1920. Peart never painted again. The artist died in 1963 and was buried at the little cemetery surrounded by her mother's brick wall.

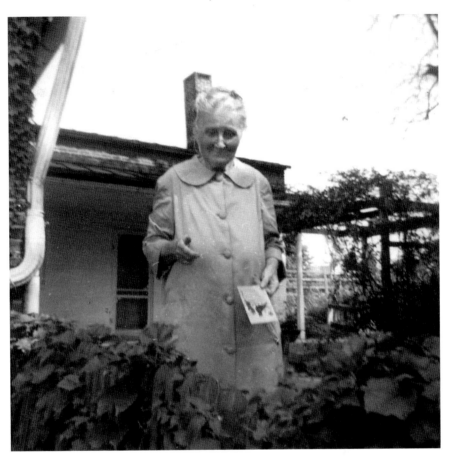

A photo of Caroline Peart taken on her ninety-first birthday, September 4, 1961, in Washington Boro. *Courtesy Franklin & Marshall College.*

Then F&M received a big surprise: Peart had willed the college all of her art as part of a $565,000 bequest in honor of her father. Income from the John Peart Foundation underwrites substantial scholarships for F&M students. In return, F&M must maintain the Herr cemetery. And the college preserves and displays Peart's art in the Phillips Museum of Art.

Faill said she believes the quality of Peart's art ranks a close third behind the work of her female peers of the period—Mary Cassatt, who spent her early summers in Lancaster, and Cecilia Beaux. Among Peart oils in F&M's collection are portraits of her parents and a Washington Boro neighbor, one of the Stamans. Many of the works are landscapes from Peart's traveling days. Another painting is in private hands. An F&M student researching

Peart is buried at the brick-walled Herr family cemetery in Washington Boro. *Photo by Jack Brubaker.*

her senior thesis several years ago discovered *Oval Mirror*, a portrait of an unidentified female subject.

It's not easy to get emotionally involved in Peart's century-old art. The walled cemetery where Peart is buried, however, tells a powerful story.

The old iron gate at the entrance is gone, but the thick brick wall is well pointed and capped with concrete. The college mows the grass inside and makes sure the tombstones stand upright.

Yes, it is a very solid place.

Caroline Peart's creative inspiration died nearly a century ago, when she was still a relatively young woman, but her cemetery is designed to last forever.

A melancholy thought.

MEMORABLE CHARACTERS

A FISHING STORY AS TOLD BY
CHARLES MILLER HOWELL

They don't make 'em like Major Charles Miller Howell anymore. Hardly anybody remembers him now, but Howell was something of a Renaissance man in nineteenth-century Lancaster. He was a soldier, gravestone manufacturer, fireman, churchman, friend of children, Mason, politician, first-rate ice skater and fisherman extraordinaire. He also could compose a humorous answer to a standard question.

But we'll get to that.

Howell was written up, along with dozens of other significant Lancastrians, in the *Lancaster Intelligencer*'s comprehensive centennial issue in 1895. He was born in 1814 in Philadelphia and moved to Lancaster in 1843. He died here in 1903. In between, he must have had a lot of fun.

Howell came from a family with military connections. His grandfather, Amos, owned the ferry on the New Jersey side of the Delaware River at Lambertville. Amos Howell helped George Washington make his famous crossing of the Delaware during the Revolution, and Washington rewarded him for that by presenting him with a horse. Henry's father, also named Amos, was a soldier in the War of 1812. Henry himself served with the state militia in Philadelphia, attaining the rank of major. This he left behind when he moved to Lancaster to enter the cemetery memorial business.

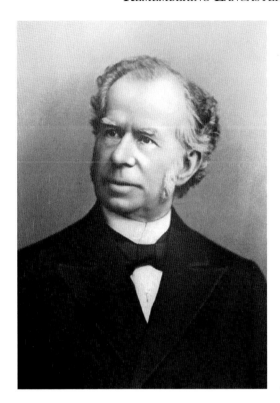

Charles Miller Howell. *Biographical Annals of Lancaster County.*

By 1895, he had been making "high-class marble and granite productions" for departed Lancastrians, first on East King Street and then at 135 North Queen, for more than half a century. Many of the finest nineteenth-century cemetery monuments in the Lancaster area were completed under his supervision. He had been active as a fireman in Philadelphia and continued that interest here as one of the chief organizers of the Empire Hook & Ladder Company and its president from 1858 to 1884. Howell served on the board of trustees of First Presbyterian Church for half a century. He was a teacher, treasurer and secretary of the Sunday school for a longer time. He was one of the incorporators of the Home for Friendless Children in 1860.

He was one of the area's most prominent Masons. In fact, so prominent a Mason was he, as a member and officer of Lodge 43 and first commander of Lancaster Commandery Number 13, Knights Templar, that Masonic lodges in Waynesburg, Chester, Safe Harbor, West Chester and York were named for him.

"Like all good Democrats," the article in the Democratic newspaper remarked, "Major Howell has always taken an active interest in politics." He

served on city council and the city school board. And in 1856, he did what it remains remarkable for a Democrat to do in Lancaster: he was elected to countywide office. He won the county treasurer's post against candidates of both the Whig and Know Nothing Parties. "From that time on," noted the article, "both Whiggery and Know Nothingism went into decay in Lancaster County." What the article failed to mention was that the new Republican Party, not the Democrats, became predominant.

But here's the gem. Asked by a reporter to tell which of his many activities he took pride in, Howell spun the following answer:

Well, the church should come first, but there are many better churchmen than I am. I'm proud of the favors bestowed on me by my Masonic brethren, but there are more worthy Masons than I. I've been lucky in politics and feel great pride in having beaten the Whig and Know Nothing candidates for county treasurer, but perhaps some other man could have beaten them more easily. I'm proud of my home and its surroundings, but, taking one consideration with another, I take more pride in black bass fishing than anything else. I go to Safe Harbor at least once a week during the fishing season, and, if I do say it myself, I think I'm the luckiest fisherman on the river. I caught thirty-one fine fellows on Tuesday last and would have gone today had the weather not been so bad.

Lancaster's Renaissance man had his priorities in order.

SAM LAZAROWITZ SOLD THE *NEW ERA* IN THE RAIN

Marjory Collins chose a rainy market day in the autumn of 1942 to snap photographs of Lancastrians passing through Penn Square. One fellow did not pass through. He remained at his post next to the Soldiers and Sailors Monument throughout the late afternoon, selling copies of the *Lancaster New Era* to motorists and pedestrians.

That man was Samuel Lazarowitz. The photo that Marjory Collins took of Sam Lazarowitz selling papers in the rain in November 1942 has become rather famous. Periodically, the picture shows up in a TV documentary, as it did in March 1982, just months before Sam died. In 2002, Michael Lesy included it in the W.W. Norton & Co. book *Long Time Coming: A Photographic Portrait of America*. The next year, Allen Cohen and Ronald Filippelli selected the photo for the Penn State University Press

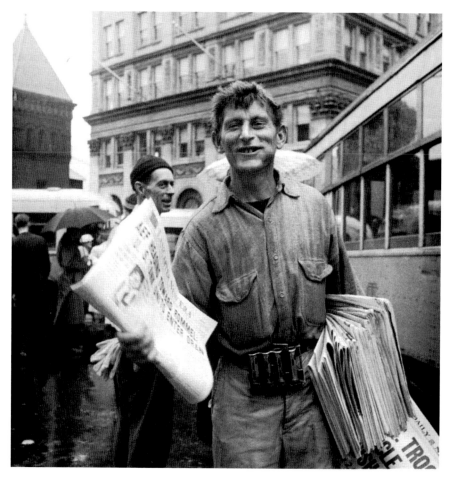

Samuel Lazarowitz sells copies of the *Lancaster New Era* in Penn Square, November 1942. *Lancaster Newspapers.*

book *Times of Sorrow and Hope: Documenting Everyday Life in Pennsylvania During the Depression and World War II.*

There are two great stories here: one about Lazarowitz, and the other about the photograph and the project that created the photograph.

When Marjory Collins took the photo, Lazarowitz had been selling papers in Penn Square for thirty-two years. At age forty, he already was as much a Penn Square fixture as the monument and the Watt & Shand department store. Longevity of service alone did not distinguish Lazarowitz from other downtown peddlers. He genuinely liked people, and when he wasn't hollering "Hi-yah, pay-per!" he was discussing politics or philosophy

with passersby. He knew Lancaster's mayors and other leaders as well as he knew his own neighbors, and if anyone ran short of trolley- or carfare home, he paid out of his own pocket.

"My dad knew everybody in town and everybody knew my dad," explained Robert Lazar, Sam's son. "Everyone respected my father and mother (Stella Miller Lazarowitz). They were very, very giving. They did things without being publicized."

Sam Lazarowitz originally sold papers and magazines from a cart at the base of the monument. When the trolley system died and cars moved by on all sides, he relocated to a corner of the square and operated a newsstand until 1958, when a new one-way traffic pattern ended his ability to sell to everyone from one location. Then he opened a luncheonette and newsstand at South Duke and Vine. Later, he ran a grocery store at 201 Church Street. He was eighty years old and had worked most of the days of his life when he died in August 1982.

The picture Marjory Collins shot of Lazarowitz forty years earlier apparently will live forever. In the photo, Lazarowitz is grinning generously in the rain, holding a couple of dozen *New Eras* under his left arm and displaying one in his right hand with a headline reading "AEF [American Expeditionary Force] HEADING TOWARD ROMMEL." Someone behind him holds an umbrella, but Lazarowitz's mop of unruly hair is bare.

"He wore no hat—no matter the weather—and he never wore gloves," his son reported. "His hands became so chapped they broke open."

Lazarowitz was not the only Lancastrian Collins photographed that day or that month. In fact, she snapped scores of pictures in Lancaster County, including an extensive series of pictures in Lititz that *Times of Sorrow and Hope* calls "probably the most comprehensive look at the effects of the war on small-town America."

Collins was one of dozens of photographers who worked for the U.S. Farm Security Administration and the Office of War Administration between 1935 and 1946. They did not limit their subjects to scenes of farms and wartime America. They were assigned to capture the spirit of the entire nation. They photographed everything. The 164,000 black-and-white pictures by Collins, Walker Evans, Dorothea Lange, Ben Shahn and other well-known photographers represent the largest documentary photography project in history. It is difficult to imagine that it ever will be equaled in scope.

Of the 150 pictures in *Times of Sorrow and Hope*, 25 were shot in Lancaster County. Most were made by Collins, who concentrated on Lancaster, Lititz and Manheim. Amish and Mennonites are the subjects of half of the 25

photos. John Collier and Marion Post Walcott joined Collins in shooting those pictures. All 25 photos are interesting, but one is particularly arresting. That is of Sam Lazarowitz with a big grin, reflecting a big heart, selling copies of the *Lancaster New Era* in the rain.

THE LAST MEMBERS OF THE HORSE THIEF ASSOCIATION

In the winter of 1999, Elmer Zimmerman and Harold Hess, two elders from the village of Intercourse, sat in a sunroom at Landis Homes Retirement Community discussing the remarkable fraternal organization they had decided to disband. Farewell, they said, to the Intercourse Association of Lancaster County, for the Recovery of Stolen Horses and Other Stolen Properties and Detection of Thieves—more familiarly known as the Horse Thief Association.

"We weren't active," said Hess.

"We couldn't be active," explained Zimmerman. "The horses were stolen before we were born."

The Horse Thief Association was founded long before these astute octogenarians arrived on the scene. In 1852, a number of prominent Intercourse horse owners decided they had suffered enough. They formed a serious association to chase after thieves. The state chartered the association seventeen years later, authorizing its president and his followers to capture bad guys who made off with their mounts. The association also was authorized to post significant rewards for those who got away. This, you understand, was before the organization of the state police.

"All the members lived in the Intercourse area," noted Hess, "but they went as far as New Holland. They went as far as Gap. They went to the Southern End. I don't know how far they went up toward Lancaster."

If anyone had stolen a horse anywhere within a reasonable ride of the Horse Thief Association, determined members saddled up and pursued, if necessary, all night long.

"I guess there was a lot of stealing back then," said Hess. "Especially horses."

"I don't see how they stole horses," Zimmerman marveled. "If they went to a barn and took one out, where would they put it? Someone would recognize it. I guess they caught a lot of those thieves right away."

"If someone was caught stealing from a widow," added Hess, "it was the worse for him."

The association flourished into this century but lost steam as automobiles began replacing horses on the highways surrounding Intercourse. Sometime in the 1930s, H.B. Slack Jr., then president, closed the association's books. But Slack was back in 1957 to help revive the organization as a fraternal society, something like the Slumbering Groundhog Lodge of Quarryville. About twenty-five members at that meeting elected Victor D. Kling president. They made Hess vice-president and Zimmerman assistant secretary treasurer. The group held an annual meeting or two, and then most of the members found other things to do. But Zimmerman and Hess remained faithful.

"We done it to keep it alive, right, Elmer?" said Hess, who worked in the livestock business and served as tax collector for Leacock Township and as Lancaster County controller before retiring to Brethren Village.

"That's right," agreed Zimmerman, who retired to Landis Homes from his work at the family hardware store, Zimmerman's, in Intercourse.

"We kept it going for the past forty years," added Hess, "and now we're just two—"

"Two old cronies," interjected Zimmerman.

"And too old and we're stuck with it," concluded Hess.

They became unstuck in the winter of 1999, deciding to close up shop and distribute the organization's treasury among four organizations: the Intercourse and Gordonville Fire Companies, the Intercourse Library and the Gordonville Ambulance Association. The Horse Thief Association's treasury never was large, as the original and unaltered bylaws required but $1.00 to join and $0.25 in annual dues. Hess and Zimmerman kept chipping in until the treasury reached $448.00. Each of the four organizations received $112.00.

"We could have let the tourist people pick up the association, but we didn't want that," noted Hess.

"They'd a picked it up and had a big thing every year with it," said Zimmerman.

"We wanted to keep the money in the community," added Hess. "If someone else had got hold of the treasury, there's no way to know what would happen to it in today's society."

And that was the end of the Intercourse Association of Lancaster County, for the Recovery of Stolen Horses and Other Stolen Property and Detection of Thieves. A century and a half of law and order and twenty-five-cent dues is history.

Hattie Brunner:
"Feisty Woman, with Great Expertise"

Following the great Susquehanna flood of 1936, Hattie Brunner traveled to a riverside farm near Harrisburg. There she examined a painted secretary that had just been pulled from a soggy shed in the flood plain. She liked the piece of furniture but did not want to pay the $2,000 to $3,000 the owner was asking. As a chauffeur drove her back to her Reinholds home, Brunner told him to stop periodically so she could call the owner and bargain by telephone. By the time she reached Hershey, the bargainers had settled on a price: $1,000. Later, Brunner took the secretary to Henry F. du Pont's home in Wilmington, Delaware. She arrived, unannounced, at du Pont's front door during a Saturday night party. A servant told her to go around back, but du Pont spotted her, invited her in and purchased the secretary. That piece is now at Winterthur, the du Pont museum.

Lancastrian Grace Buckwalter told that story to illustrate Hattie Brunner's tenacity as Lancaster County's first great collector of folk and decorative art. Buckwalter had interviewed Brunner and had done further research on the Reinholds woman's life.

Hattie Brunner, collector of folk and decorative art and painter of rural Lancaster County scenes.
Lancaster Newspapers.

Born in 1889, Brunner began her career as a musician. She played piano and graduated from the Philadelphia Academy of Music. She later played the organ and sang soprano in the choir at the Swamp Church in Reinholds. But Brunner discovered she had many talents and spent most of her life as a dealer in antiques and, later, as a renowned folk artist. "Hattie had a talent for, first of all, knowing what her talents were," Buckwalter said, "then developing them and choosing the right path when the opportunity knocked."

Brunner began collecting Pennsylvania Dutch folk materials in the 1920s. She was one of the first Lancastrians to realize how great the demand for Pennsylvania Dutch arts and crafts would be. She taught herself how to recognize fine objects by attending auctions and closely examining antiques.

"She introduced Pennsylvania folk art literally to the world by opening her booth at the 1926 Philadelphia sesquicentennial," Buckwalter said. "And within five years after that, she filled her booth at the second Philadelphia Antique Show with choice selections from her own shop."

Brunner spoke fluent Pennsylvania Dutch, so farmers trusted her when she came calling at individual homes to buy old family treasures. She turned around and sold these pieces to famous men and museums. Brunner's clients included du Pont, Colonel Albert Barnes and Horace Lorimer, editor of the *Saturday Evening Post.* When well-known people arrived to examine objects at Brunner's Reinholds home, Buckwalter said, local residents would remark, "Um, the big muckety-mucks are here today."

At age sixty-seven, Hattie Brunner began another career—as a "memory painter." She started by helping her grandson learn to paint and continued when he lost interest, completing more than six hundred watercolors before dying at age ninety-two in 1982. "Hattie painted strong, colorful, nostalgic scenes based on memories of her life in Lancaster County," Buckwalter said. "From years of dealing in antiques and Pennsylvania Dutch crafts, she possessed a really cultivated eye and a good sense of design. Her technical skills really were self taught."

Many compared Brunner to Grandma Moses, a comparison the artist discouraged. Grandma Moses had begun painting as a child, Brunner pointed out, whereas she began painting as a grandmother. "My work," she said simply, "is the result of having lived a while."

Brunner, who sold her first painting for five dollars, would be surprised to know that several of her works have sold for five figures in recent years. The paintings are popular, Buckwalter said, because of their bright colors and happy nature. "Her paintings show only the harmonious, the tranquil aspects of rural life," noted Buckwalter. "Her unselfconscious style adapted

Brunner often painted scenes of auctions she attended in Lancaster and nearby counties. *Courtesy Landis Valley Museum.*

colors, shapes and symbols that filled her life—that is, auctions, sleigh rides, church—they all tell stories, grandma-style, of life when she was young."

Brunner never owned a television set, never drove a car and did not like to travel, Buckwalter said, so she had time to work on her painting as she aged. She did not stop until poor eyesight and arthritis intervened when she was eighty-nine.

Brunner was "a feisty, outspoken woman, with great expertise, who smiled often, laughed easily (with a Pennsylvania Dutch inflection that said, 'I don't try to hide')," Buckwalter noted, in summing up Brunner's life and character. She said the artist "accepted life as she found it, worked hard every day, knew who she was and where she was going, while remaining close to her plain and simple roots in rural Lancaster County."

"Jack" Zook of Paradise Popularized Hex Signs

The symbol most universally connected with Lancaster County may not be the red rose or the Conestoga wagon or even an Amish silhouette. When

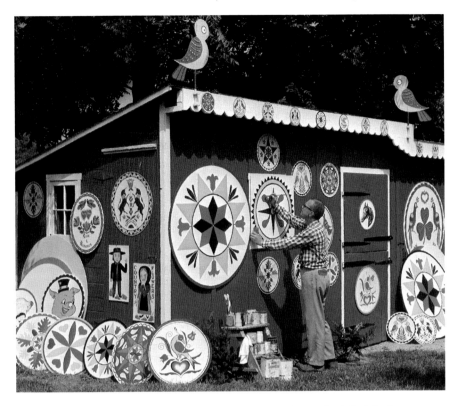

Jacob Zook painting a hex sign outside his Paradise shop. *Courtesy Jacob Zook family.*

tourists close their eyes and try to picture Lancaster, many of them probably see hex signs.

Few authentic hex signs exist on the sides of barns in Lancaster County, but people come here to buy the repros.

Hex signs and Lancaster are joined today largely because of the work of Jacob G. Zook. Known to his friends as "Jack," and known to the world at large as the "Hex Man of Paradise," Zook left his hex designs behind when he died in 2000 at the age of eighty-five.

Zook and his wife, Jane, began silk-screening hex signs at their Paradise shop in 1942. They designed their own signs and used other designs by Johnny Ott, a colorful Berks County hotelier. Over the years, Zook created a worldwide distribution system for his silk-screened signs. After Jane Zook died, daughter Jane helped with the business. The Zooks published a little booklet, *Hexology: The History and Meaning of Hex Symbols*. That booklet promoted the signs' potential value as talismans. Zook enjoyed hearing

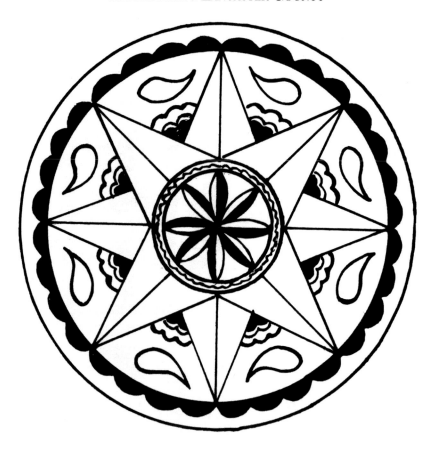

A California couple used this "rain, sun and fertility" hex design by Jacob Zook to help them make a baby. *Lancaster Newspapers.*

from people who thought his hex designs helped them deal with life in some way. For example, happy grandparents in Glendora, California, wrote to Zook. They had purchased his fertility hex sign. They gave it to their son and daughter-in-law, who put the sign under their bed. The grandparents wanted Zook to know about their new grandchild.

Jack Zook would have been pleased to know that he is featured prominently in the second edition of *Hex Signs: Pennsylvania Dutch Barn Symbols and Their Meaning.* If you want to know all about hex signs, the book by folklorists Don Yoder and Thomas E. Graves is the only thing you need to read. You don't even need to read it. You can get much of the idea by scanning the scores of full-color photos of hex signs and "hexology" related to the signs.

Stories from Pennsylvania Dutch Country

The main points about hex signs that any knowledgeable Lancastrian should know are:

1. The Amish and other Plain people have never used gaudy hex signs (a point that Jack Zook made clear in his hexology booklet).
2. Other Pennsylvania Germans painted authentic hex signs on barns beginning in the 1860s. The signs that Jack Zook and others created on various surfaces for sale to tourists are spinoffs from the barn-side originals.
3. Only a handful of barns in northeastern Lancaster County sport hex signs. Most signs are located in Berks County and north. The most common design in Lancaster is the eight-point star with small secondary points between the main ones. This is called the Cocalico Star, after the Cocalico Creek.
4. Hex ("witch" in German) signs may or may not have any meaning beyond their pure design. Probably they don't.

Yoder and Graves explain how tourism has exploited hex signs in Lancaster County:

> *The tourist agencies continue to mingle the hex signs with Amishmen to attract tourists to the Dutch Country. This is especially true of Lancaster County, to which five million tourists a year flock to see the Amish. It is almost a losing battle, but at least the scholars have gone on record in separating the classic traditional signs and traditional explanations of them from the work of hexologists.*

Jack Zook was not in business to confuse anyone about the origin or meaning of hex signs. He was in business to make money and to have fun. His fun-loving nature prompted him to tell many eye-widening stories. Here's one.

One of Zook's farming neighbors lost the underground water line from his well into his house on washday. The water froze and burst the pipe. So the farmer ran another 250-foot water line on top of the ground. The temperature that night dropped to zero. The second water line burst. So the farmer set out a third pipe line and covered it with fifteen inches of horse droppings. Then he covered the manure with ten inches of unused straw. The manure gave off heat, the straw provided insulation and the third water line did not break.

That was the kind of story that really amused Jack Zook, a twelfth-generation Pennsylvania Dutchman who appreciated the old ways as much as the new and never lost his childlike fascination with unusual stuff.

THE AMISH AND PENNSYLVANIA DUTCH

AMISH WENT TO JAIL TO PROTEST SCHOOL LAWS

In September 1950, Lancaster County school districts arrested dozens of Amish fathers who refused to send their fourteen-year-old children to school. Six of those men lived in Bart Township. One of them was Levi Esh. Esh's daughter, Mrs. Jacob Flaud of Newburg, Pennsylvania, wrote a brief description of her father's arrest and how she felt about it at the time for the November 1997 issue of the *Diary*, a monthly newspaper of the Old Order Amish.

The Amish struggled for years to keep their children from attending high school. Opposed by state and local educators and legislators convinced that right was on their side, the Amish had to dig in their heels. In the spring of 1949, the Pennsylvania legislature raised the compulsory school age from fourteen to sixteen, unless a child was excused for farm or domestic work. The legislation gave the state superintendent of public instruction authority to approve these excuses. He approved few.

Beginning that fall and continuing through the fall of 1953, scores of Amish fathers went to Lancaster County Prison, sometimes for several days, for refusing to send their fourteen-year-olds to school. The Amish finally persuaded the state that they would educate their own kids after they completed eighth grade. They opened the first vocational school in an Amish home in January 1956. Children spent three hours a day with Amish teachers studying basic subjects and worked the rest of the week.

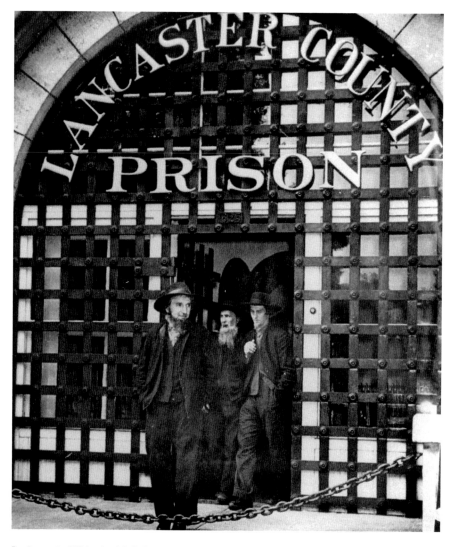

In the early 1950s, Amish fathers were jailed for not sending their children to public schools. These men have just been released. *Lancaster Newspapers*.

This program continues, although the state's mandate was voided in 1972 by a U.S. Supreme Court decision that gave the Amish the absolute right to withdraw their children from high school for religious reasons.

Living in an Amish family disrupted by the emotional turmoil that accompanied the arrests of 1949 and the early 1950s must have made an impression on many children. It affected Mrs. Flaud, as she told the *Diary*:

In September of 1950, some parents were fined for not sending their children to school after they were 14 years old and through the eighth grade. They had a choice to pay a fine or go to jail. They decided not to pay the fine. Six of the men from Bart Township were put in jail. They were John Glick, Sam Stoltzfus, Dan Zook, Abner Glick, Enos King, and Levi Esh (my father). Dad used to say they were the first to get jailed, so they didn't know how long they'd have to stay. The next day, however, they were released. Charlie Hassel, a school director, was there to take them home. They didn't know who paid the fine. I remember my mother being very tense but also trying to be brave...I remember, too, that at the time, the sky looked very different. It was sort of pink all around. It sort of scared me.

Levi Esh and his friends opposed high school education for many reasons. These reasons included their religious teachings, a keen interest in keeping schools and students close to home and a concern that advanced "book learning" would lead children away from farm life.

When Elizabethtown College professor Donald Kraybill, author of *The Riddle of Amish Culture*, asked an Amish school leader why the community opposed progressive education, the Amish man said: "With us, our religion is inseparable with a day's work, a night's rest, a meal, or any other practice; therefore, our education can much less be separated from our religious practices." And an Amish farmer added, "They tell me that in college you have to pull everything apart, analyze it and try to build it up from a scientific standpoint. That runs counter to what we've been taught on mother's knee."

To keep their children from being separated from Amish society, the Amish endured persecution that only began with those days in prison. The state worked hard to embarrass the Amish by spotlighting their "ignorance." Lesser men would have caved in to that pressure.

What the Amish experienced in prison may not have been so different from what Henry David Thoreau learned when he spent a night in jail in 1845 for refusing to pay poll taxes. That was his way of protesting the government's protection of slavery. Thoreau discovered that the government could not humiliate him because he was right. He felt that those on the outside of the bars were imprisoned, not he. "I was not born to be forced," he wrote in *Civil Disobedience.* "They only can force me who obey a higher law than I."

The Amish similarly took comfort from their time behind bars. In *Amish Society*, Temple University sociologist John Hostetler said Amish men returned from jail "stronger in their faith and more secure in their convictions...It enabled them to identify with the martyrs among their forefathers."

POETRY CALMED COMMUNITY
AFTER SCHOOL SHOOTINGS

During the week after the Amish schoolhouse shootings in October 2006, several people who reside near the school in Bart Township said they saw a rainbow. So the *Diary*, the Old Order Amish monthly that is published in Bart Township, printed a poem about a rainbow on its front page. "The Rainbow" signifies love, hope and care, according to the poem by M.S. of Wisconsin. The poem concludes: "His grace is sufficient, His strength will be with me / The skies of tomorrow shine blue!" Amish employees of the *Diary* decided that the rainbow poem, written independently of the shootings, would make an appropriate front-page statement for the first publication following the tragedy.

Quiet rainbow poetry v. blaring headlines and satellite broadcasts by the rest of the world's media.

The Amish reporting of the shootings was straightforward and subdued, reflecting the way the plain community viewed the incident. On its front page, *Die Botschaft*, an Amish and Mennonite weekly newspaper published in Millersburg, Dauphin County, printed a letter from the Amish community thanking everyone who had helped in a time of distress. Some of the letters inside addressed the shootings.

Like *Die Botschaft*, the *Diary* is largely composed of letters from scores of Old Order correspondents who live all over the United States. Most of the

A horse-drawn Amish buggy passes the schoolhouse where an intruder shot ten Amish girls in October 2006. *Lancaster Newspapers photo by Dan Marschka.*

letters in the October 2006 issue of the *Diary* were written in September, so there were few comments on the October 2 shootings. Much commentary addressed everyday events of life, including the following note from Rebecca Glick of Strasburg: "Friendly Greetings to whoever cares to read a few lines. We just came back from an evening stroll and autumn is in the air, my hands got a bit cold, before we know it the wedding bells will be ringing. We only expect 4 or 5."

The *Diary*'s editor did include death notices of the five Amish girls under "Obituaries." And because there is no news category titled "Homicides," he inserted a story about the shootings under "Accidents."

"I asked Amish who work here how they felt about this," the editor commented to a newspaper reporter. "They said they didn't want more fuss."

So the Amish themselves composed a very simple story. It began:

> *Paradise, PA.—The whole community was shocked on Monday noon, Oct. 2, when the news came out that a man with a gun entered the W. Nickel Mines School. He did not at first seem so very threatening.*

The report explained how the gunman released the teacher, visitors and boys and held ten girls, eventually shooting them all, killing five, before state police broke into the school and found he had shot and killed himself as well. The story named the victims, but not the gunman, and concluded:

> *He was a local milk truck driver, and seemed like a friendly man. Pages could be written about the whole incident, but it would not change anything, so we must just accept it, and move on. Let go and let God. He is still in control.*

The Amish grieve like everyone else, but their decision to accept God's will in all things and to forgive the sins of others seems to help them put such "accidents" into perspective more easily than many of us.

Here's another way to look at that. An Ontario Amish woman, writing in the Amish monthly magazine *Amish Life* many years ago, described how she felt about losing her baby, who died soon after birth. "Of course, all the time the question 'Why?' comes to our minds," she wrote. "But we should not expect to be able to understand everything in this life, and should never put a question mark where God has put a period."

So life goes on.

PLACE NAMES:
NOODLEDOOSEY TO *BISSKATZELOCH*

C. Richard Beam was born at Red Run, a hamlet near a stream by that name in East Cocalico Township. But if you ask the director of Millersville University's Center for Pennsylvania German Studies where he first saw the light, he does not say Red Run. He says *Die Rot Kuh. Die Rot Kuh* is Pennsylvania Dutch for "the Red Cow."

So how do Red Run and Red Cow relate?

"I don't know, except that the hotel there was called the Red Cow," explained Beam. "The hotel sign showed a red cow."

Die Rot Kuh is one of many Pennsylvania German place names in the Ephrata area. *Die Rot Kuh* is the only name that includes an actual color, but they are all colorful words.

Just west of *Die Rot Kuh* is *Noodledoosey*, the most colorful of all. *Noodledoosey* actually is off-color. Two men and a woman were involved in a popular

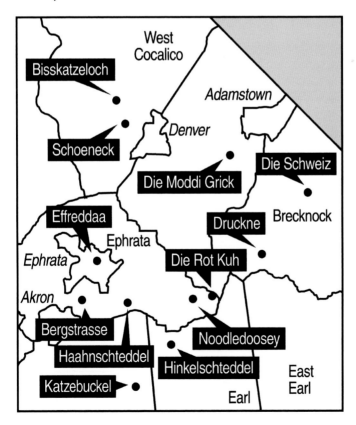

Pennsylvania Dutch place names in northeastern Lancaster County.
Map by Chris Emlet.

108

activity outside a meetinghouse at that location when one of the men said to the other—ah, well, you'd better let Dick Beam tell you the story.

Farther east in East Cocalico is *Druckne*, the Pennsylvania Dutch term for Fivepointville. Whereas Fivepointville is named for the junction of five roads, *Druckne* simply means "Dry." The English nickname for the area is "the Dry." "It's elevated a little bit, so most of the water that fell up there could run away," suggested Beam, "but I can't explain it otherwise." Also, the old Dry Tavern, *Es Druckne Wattshaus*, operated at Fivepointville.

Northeast of *Druckne*, in Brecknock Township, is *Die Schweiz*, a section of small, dense growth just short of the Bowmansville Woods. *Die Schweiz* is, literally, Switzerland. The area apparently reminded early Mennonite settlers of their homeland.

To the west, *Die Moddi Grick* (Muddy Creek) is the creek, of course; but it is better known to old-time-dialect speakers as the area where Route 222 intersects with the Pennsylvania Turnpike. If you want to eat at Zinn's Diner, you have to drive up to *Die Moddi Grick*.

Dropping well to the southwest, down in West Earl Township, is *Katzebuckel* or "Cat's Back." That's the name of the hill at Fairmount, where Fairmount Nursing Home is located. Beam says there is a Katzebuckel mountain in southern Germany, so the derivation of this word is clear.

Nearby, in Ephrata Township, lie Hahnstown and Hinkletown—two names that provoke much mirth among speakers of the Pennsylvania Dutch dialect. *Haahneschteddel* means "Rooster Town," and *Hinkelschteddel* means "Hen (or Chicken) Town." But the late Henry Snyder Gehman, a Princeton Theological Seminary professor who grew up in that area, said Hahnstown was named for a Hahn family, not a rooster. And Lancaster historian John W.W. Loose says Hinkletown actually was named for a settler named Hinkle. So the relationship of the two Pennsylvania Dutch place names may be entirely coincidental.

A little farther west, where Routes 222 and 322 intersect in Ephrata Township, is *Bergstrasse*. This is the high-German spelling, Beam says. Pennsylvania German would be *Die Barigschtrooss*. Either way, it means "the road over the mountain," from *Bergstrasse* to Ephrata. That's *Effredaa*, by the way, as pronounced in the dialect.

Now let's move north to Schoeneck in West Cocalico Township. This place apparently was named by a wide-eyed itinerant who looked around himself and said, "*Das ist eine schoen eck.*" ("This is a beautiful corner.")

About a mile north of Schoeneck is *Bisskatzeloch*, or "Polecat (Skunk) Hollow." Beam doesn't know how this place got its name. Not everyone likes

to say *Biss*—a word that employs a different first letter in English. So some call a polecat *Schtinkkatz* and the place *Schtinkkatzeoch.*

"This does not exhaust all the Pennsylvania Dutch names in Lancaster County," explained Beam. "This just takes care of the Ephrata area."

Then there are all the dialect terms for the English place names that predominate in Lancaster County. *Lengeschder*, for example, is what dialect speakers call Lancaster City.

"PRINCIPAL SYMBOL OF THE PENNSYLVANIA DUTCHMAN"

Groundhog Day is a special holiday throughout Pennsylvania Dutchland, although the Germans did not start the custom. The day's origins are pagan. The Celts celebrated February 1 as one of the four turning points of the year. Christians appropriated the day as Candlemas and extended its observance to February 2. Secular celebrants eventually turned it into Groundhog Day.

Groundhog Day is the day that TV weather forecaster Bill Murray wakes up at 6:00 a.m. in Punxsutawney and wakes up at 6:00 a.m. in Punxsutawney and wakes up at 6:00 a.m. in Punxsutawney over and over and over again and again and again.

Oh, wait a minute, wrong *Groundhog Day.*

Groundhog Day is a book by University of Pennsylvania folklorist emeritus Don Yoder in which the author gives Punxsutawney and Quarryville their due as special American places where the rite of whistle-pig weather-watching perseveres.

Punxsutawney is, indeed, "Weather Capital of the World," and Yoder explores that world in depth. He begins with an account of the wild and crazy February 2 festival at Punxsutawney's Gobbler's Knob, "the sacred gathering place of American Groundhogism." On Groundhog Day, Punxsutawney Phil emerges from his Punxsutawney Borough, Jefferson County burrow and determines the weather for the next six weeks. If Phil can't see his shadow, spring is nigh. If Phil can see his shadow, expect six more weeks of bad weather. Punxsutawney traces its Groundhog Day history back to 1886—but who cares?

The more significant Groundhog Day celebration (at least in these parts) is held in what Yoder terms "Pennsylvania's second major center of the Groundhog Day cult"—Quarryville—in southern Lancaster County. The Slumbering Groundhog Lodge has been assembling at Quarryville since February 2, 1908.

Top-hatted members of the Slumbering Groundhog Lodge of Quarryville celebrate Groundhog Day in 1955. *Lancaster Newspapers.*

George W. Hensel Jr., founder of the Slumbering Lodge, was quite a fellow. He was a Quarryville postmaster and bank president. He served on county and state Democratic committees. He wrote a regular newspaper column for the *Philadelphia Inquirer.* And, if he were still kicking on February 2, Hensel no doubt would be one of the most enthusiastic lodgers, wearing top hat and nightshirt and reciting the Groundhog Creed, which concludes: "To defend (the groundhog) with all our might, and at all hazard, we pledge ourselves, our man servants and our maid servants, our oxen, our asses and our assets as a whole."

Yoder also describes Groundhog Day festivities elsewhere in Pennsylvania and in Maryland, Virginia and Wisconsin (and Oxford, Michigan, where Noah the One-Eyed Groundhog died and was replaced by Mr. Prozac, a llama)—but who cares?

Closer to home, the Old Order Amish, "who pride themselves on rejecting certain aspects of common Pennsylvania Dutch folk culture, like the Christmas tree and the Easter rabbit," notes Yoder, nevertheless recognize the groundhog weather prophesy of Candlemas. Six decades ago, an

Oregon Amish woman wrote to the national Amish newspaper, the *Budget*: "The groundhog could see his shadow very plainly on Sunday if there were any groundhogs here, which there aren't, anyway the old ruse about having six weeks of winter isn't very reliable in Oregon."

Yoder's folklore specialty is Pennsylvania German culture, and he discusses Pennsylvania Dutch Groundhog Lodges at some length. These lodges, designed to foster "groundhogism," the Pennsylvania Dutch dialect and Dutch humor in general, have made the groundhog "the principal symbol of the Pennsylvania Dutchman." The first Grundsau Lodge met in Northampton on Groundhog Day 1934. Now there are nineteen such lodges in Pennsylvania, all north of Lancaster County, as well as sixteen *Fersammlinge*, similar gatherings where men congregate to joke around in the dialect. In recent years, Pennsylvania Dutch women have begun their own lodges in Montgomery and Lehigh Counties.

Yoder's entertaining book is filled with fascinating miscellany, including poems and songs celebrating the hog. For example, top-hatted, white-shirted Quarryvillians sing "February Second" to the tune of "John Brown's Body." Its first verse goes:

> *Let the scientific fakirs gnash their teeth and stomp with rage—*
> *Let astrologers with crystals wipe such nonsense from the page—*
> *We hail the King of prophets, who's the world's outstanding Sage—*
> *Today the Groundhog comes!*

Groundhog Day rules!

COMMENTARY

STATION ON THE UNDERGROUND
RAILROAD DESTROYED

First published July 25, 1986

Of the forty-seven architecturally and/or historically significant structures in Upper Leacock Township listed by the Historic Preservation Trust in its 1985 compilation of hundreds of such places in Lancaster County, the Gibbons House is first named. Several of the trust's descriptive facts are wrong, especially as it confuses the relatively modest 1815 stone and brick Gibbons House on Beechdale Road north of Bird-in-Hand with a large limestone Victorian house about fifty yards away on the same property; but the designation suggests the building's importance.

The Gibbons House was used as a primary Underground Railroad station in Lancaster County—and therefore as one of the foremost such stations in the country—from its construction until the Civil War. Quakers Daniel and Hannah Wierman Gibbons built the house on part of a 1,060-acre tract, much of which had been deeded to Daniel's grandfather, James Gibbons, by William Penn's sons in the early 1700s. Daniel's father, also a James Gibbons, was the first to settle on that land. He built a mill on the Old Philadelphia Pike, about half a mile down Mill Creek from the house. He was the first in the family to process escaped slaves on their way north from Maryland. Daniel and Hannah

The Gibbons House in Upper Leacock Township was used as a station on the Underground Railroad. *Courtesy Jack Brubaker family.*

Gibbons helped about one thousand slaves during the decades they operated the station at the up-creek property, later known as Beechdale Farm.

The Gibbonses used everything short of violence to harbor and transport slaves. Upon arrival, Negroes were hidden in a nearby barn. Each received a new identity to take on his or her way. If a master was not in hot pursuit, slaves occasionally remained for a while to work in the neighborhood.

Daniel and Hannah's son, Joseph, continued to operate the Underground Railroad station. A physician, Joseph was active with the Liberty Party and a founder of the Republican Party in Pennsylvania. He edited the national Quaker publication, the *Friends Journal.* Joseph's wife, Phebe Earle Gibbons, authored a book that is still quoted on the plain sects, *Pennsylvania Dutch and Other Essays,* and wrote for *Atlantic Monthly* magazine.

While aiding escaped slaves, these people subscribed to just about every antislavery newspaper in America. They kept hundreds of issues of these papers in a large trunk that eventually landed on the third floor of the Gibbons House. That floor also featured a long segmented closet running beneath the sloping roof. Those with a vivid imagination could believe that slaves were hidden there, although it is more likely that they were kept outside the house in case of a master's raid.

Over the years, the house became a landmark in Upper Leacock Township. After James R. Coson, a California businessman and carriage collector, purchased Beechdale Farm in 1984, he restored the exterior of the building. Like all of the owners of the farm since the limestone home was built in 1909, however, he lived in the big house.

One day this summer, on one of his infrequent visits to Pennsylvania, James Coson decided to change the view from the stone house. So he demolished the historic house he had restored. Number one on the list in Upper Leacock Township is history.

So it goes.

The Scribbler spent his first six years in the limestone home near the Gibbons House on Beechdale Farm. It was the Brubaker Brothers Duck Farm then, and the Brubakers thought the whole thing would last forever. The Scribbler's great-grandfather, Oram David Brubaker, surely thought the same when he married Marianna Gibbons, daughter of Joseph and Phebe, and built the limestone house. But the duck business didn't last forever, and neither did the Gibbons House. After the duck farm was sold in 1961, several owners altered the property. Coson's demolition was one of many uncoordinated projects.

So what? It's a free country. You pays your money and you takes your choice. Life is change. Supply your own cliché.

It remains depressing that a building that had as much historic merit as and more symbolic value than many of the better-known historic homes in Lancaster County has been destroyed on a whim. Our heritage has been harmed without a hearing.

NORTH QUEEN STREET, ONCE MOVIE HOUSE ROW, GOES DARK

First published July 7, 2000

In *Of a Place and a Time: Remembering Lancaster*, a reminiscence of this city between the two world wars, Richard D. Altick comments on a phenomenon that he and other moviegoers experienced upon leaving the several theatres in the second block of North Queen Street:

The memorable sensation of the moment lay in the psychic distance that separated us from the people on the sidewalk: they did not know, could

not know, the pleasures of the artifice that had lately enveloped us... The
transition to the commonplaces of the Lancaster scene was a momentary
shock, like suddenly switching from warm to cold water in a shower.

The cold water of reality certainly showered Lancaster moviegoers as they filed out of the United Artists Pacific Theatre on North Queen Street Wednesday night. They composed the last audience. After rolling the reels of *Chicken Run* and *Gone in 60 Seconds,* the theatre closed its doors forever. For the first time in nearly a century, Lancaster City has no movie theatre.

No matter who is primarily responsible—the struggling United Artists chain that prematurely closed an apparently successful operation or the Red Rose Transit Authority that plans to purchase the property and tear it down to build a new bus terminal—the result is bad news for Lancaster. This severely limits the options for evening entertainment in the city. People can eat in restaurants. They can attend Fulton Opera House shows. They can drink and dance in a nightclub. What else can they do? Teenagers are especially deprived of entertainment. If they are old enough to drive, they can exit to a suburban megaplex with a dozen or more movies playing on puny screens not much bigger than some people have in their rec rooms. But what can they do in the city? Even the old driving Loop through downtown Lancaster is *verboten*.

No matter who is responsible, shutting down the last movie house in town represents atrocious planning, and it throws a big bucket of cold water on this city's nightlife smack in the middle of the summer theatre season.

This is not the first time.

North Queen Street used to be the city's theatre row. The Nickelodeon, Lancaster's first real movie theatre, opened at 141 North Queen before 1906. Of several other early theatres on that strip, the Dreamland, at 43 North Queen, lasted longest. Later, in the '20s, '30s,'40s and '50s, theatres lined North Queen Street: the Grand, the Scenic, the Hamilton, the Colonial (later called the Boyd) and the Aldine (which later was rebuilt as the Capitol). A second-run movie house called the Strand, as if not welcome to join the royalty on Queen, opened on Manor Street. Redevelopment of the Second Block of North Queen in the mid-1960s leveled all four remaining theatres and a lot of other wonderful buildings in a paroxysm of urban destruction whose reverberations continue to shake this city. Redevelopers closed the North Queen Street theatres in late July 1965—smack in the middle of the summer theatre season.

Even after the redevelopment bomb hit North Queen, and as late as the early 1980s, the city boasted five movie houses with eleven screens. They

The Colonial Theatre on Lancaster's North Queen Street, 1943. *Lancaster Newspapers.*

included the Pacific, the Eric in the rebuilt Brunswick Mall, a movie house at Park City shopping center, the Fulton Opera House on Prince Street and the King Theatre out on East King Street.

The Scribbler spent most of his moviegoing time in the latter two. In the late 1950s and '60s, before its renovation as a legitimate theatre, the Fulton

ran films such as *Alfie* and *Belle de Jour*. The theatre was shabby then, but the screen was huge and the movies first-rate. The King, being the closest indoor theatre to the Scribbler's home in Bird-in-Hand, was *numero uno*. At the King, which opened in 1950 showing *Ma and Pa Kettle Go to Town*, the Scribbler spent the most awkward theatre night of his life.

For a time in the '60s, the King, like the Fulton, showed art films. Many of these were foreign made. One was *Dear John*, a 1964 Swedish film described as "sensuous." It featured much more to watch than the subtitles.

The Scribbler's father was not a particularly adventurous filmgoer, but the Scribbler (a relatively naive college sophomore who knew nothing of the movie's content in advance) managed to convince his dad to go see *Dear John*. Father and son sat there, bonded in abashment, for two extremely uncomfortable hours before the screen went dark and released them to reality, which, in this case, presented no "momentary shock" but blessed relief.

Is it possible that no local teenager will ever again be able to drag his dad to a "sensuous" movie in Lancaster City and then seriously consider joining the bubble gum under his chair rather than sitting up straight and taking his embarrassment like a man? If that is really all, folks, then the Scribbler would like to quote his dad, who liked to quote the old-time actor William Bendix on such occasions: "What a revolting development this is!"

THEY WANT TO BUILD A WALL, BUT THERE'S A BETTER WAY

First published April 11, 2003

Garden Spot Village and Retirement Community objects strenuously to a plan to run a Route 23 bypass through its Earl Township property. The large and expanding retirement home opposes its proposed mutilation for several reasons. Let's focus on one of those reasons.

The so-called southern alternative for a new Route 23, currently designed as a four-lane spear through the heart of eastern Lancaster County's agricultural community, would be elevated far above the farmland it would bury. That elevation would allow the high-speed bypass to cross bridges over existing roads that bound Garden Spot Village and feed into New Holland. The bypass would run on top of a twenty-five-foot-tall solid wall of earth. This earthen wall would extend for miles through the Mill Creek Valley. Not only would the wall bisect Garden Spot Village's property, but it also would

cut off the view to the south from New Holland homes and to the north from Mill Creek farms. On top of this wall, state highway engineers propose to attach ten-foot-tall sound barriers to lessen the impact of bypass racket on the surrounding area. So the entire structure would stand thirty-five feet tall—roughly the height of a three-story building—and loom over many of the buildings in New Holland and the Mill Creek Valley.

Both New Holland and Earl Township restrict the height of residential buildings to thirty-five feet. Commercial and industrial buildings may rise higher, but most structures in the area would look up to the wall.

"Many of our residents chose to live at Garden Spot Village because of the bucolic environment and the spectacular views of the Welsh Mountains," notes Garden Spot Village's opposition statement. "Replacing that wonderful view with a 35-foot wall would adversely affect the marketability of the campus."

Well, you can imagine.

Or if you cannot imagine a thirty-five-foot-tall solid wall running for miles through the bucolic eastern Lancaster County countryside, consider the flood-control levees that separate Wilkes-Barre and Kingston from the Susquehanna River in the Wyoming Valley. Those levees rise to something over forty feet. The only way you can see the water on the other side of the earthen walls that run for miles along both sides of the Susquehanna is to climb up and over the levees, cross a river bridge or look out a window of a building four or more stories tall. Many Wyoming Valley residents don't think of themselves as living beside a river. They live behind a levee.

If bypass boosters who favor the southern alternative do what they want to do, residents of New Holland and Mill Creek Valley no longer will live in a small town or a farming community. They will live along an elevated highway.

But there is another way to do this.

Actually, there are eight other proposed alternatives, all of which would be less intrusive on the landscape and less expensive to build. Unfortunately, all of the other ideas are less attractive to Lancaster's political and industrial leaders, who are wedded to the southern alternative.

So, if they won't settle for anything less than a $200 million farm-bisecting bypass, let's sink it. Dig twenty-five feet into the ground and run the highway beneath existing roads instead of over them. A depressed highway still would cut through Garden Spot Village property but, tucked out of sight, would not ruin the landscape.

What's that? Does the Scribbler hear faint howls of derision from highway engineers who believe digging down rather than building up is a stupid idea? Well, let's see.

In a landmark 1990 book, *The Experience of Place*, author Tony Hiss commended just such an idea put into practice. That is the Pennsylvania Railroad's Low-Grade Line, built a century ago to carry trains from Atglen, Chester County, across Lancaster County to the Susquehanna River at the most minor possible grade. The Low-Grade (now abandoned by trains and proposed as a rail-trail across southern Lancaster County) runs as much as eighteen feet beneath ground level to maintain its grade. Sometimes the line runs at ground level or crosses bridges over sunken roads, but always the grade is even so a viewer never sees an abrupt imposition on the landscape. Hiss applauded the Low-Grade for its unobtrusive sweep through farmland. He said the nation needs more such projects to prevent modern sprawl from overwhelming unique landscapes. He called the Low-Grade a "Pennsylvania landscape of tomorrow" where "a hulking new piece of transportation infrastructure was installed in a way that respects small pictures and ordinary perceptions."

It would be considerably less intrusive and expensive to reconstruct the present Route 23 than to run a bypass anywhere south or north of it. But if the "Amish Throughway" developers succeed in ramming their alternative through Mill Creek Valley...well, at least put that hulking new piece of transportation infrastructure where the rest of us don't have to look at it.

REVIVE RIVER TOWNS WITH WATER RECREATION

First published July 1, 2003

Civil War reenactors burned a bridge between Columbia and Wrightsville Saturday night. In so doing, they built a bridge between the river towns and thousands of area residents who came to watch the simulated conflagration.

Rivertownes, an organization representing Columbia, Wrightsville and Marietta, sponsored the reenactment of events 140 years ago. They called it "Flames Across the Susquehanna." The evening's major activity involved igniting piles of firewood on each of the piers remaining from the covered bridge Union forces burned on June 28, 1863, to keep Confederate soldiers from crossing the Susquehanna River into Lancaster County. The lighting began at 8:00 p.m. and concluded after 10:00 p.m., when the fires extended for more than a mile between Wrightsville and Columbia. Meanwhile, Confederate reenactors fired cannons toward the bridge ruins from the Wrightsville side. Event sponsors played period music from large speakers in

Spectators on the Route 462 bridge over the Susquehanna look upriver toward piers of the old bridge about to be "burned" during a June 2003 reenactment. *Lancaster Newspapers photo by Blaine Shahan.*

the middle of the Route 462 bridge, just downstream from the burned span. Independent parties set off fireworks upstream and downstream.

The extraordinary display entertained thousands of spectators who lined the Route 462 bridge and stood dozens of ranks deep along both banks of the river.

But the best view was from the water, where scores of boats—motorboats, pontoons, canoes, kayaks—floated in a manageable current just upstream from the burning piers. The Scribbler and Mrs. Scribbler kayaked down from Accomac, on the Susquehanna's York County shore. We enjoyed a balmy night, the crackling pier fires, cannon fire echoing along the 462 bridge arches and "Aura Lee" and "Garry Owen" blaring from the loudspeakers and resounding on the water. Music was crucial to the atmosphere. Not only did its continuous playing enhance the sense of being transported to another time, but also the old tunes drowned out motorboat boombox racket that otherwise would have destroyed the show.

Henry David Thoreau said that viewing the earth from the water provides an extra kick to life. He wrote, "I vastly increase my sphere and experience by a boat." Those of us anchored or languidly paddling in the Susquehanna during the festivities appreciated just such an otherworldly impression of this event.

Rivertownes should build on that feeling. It's the best thing the old river towns have going for them.

Historically, the Susquehanna has been these villages' most vital element. It has provided drinking water, a place to dump sewage, a source of water for industry and a rich fishing resource. Massive amounts of lumber and thousands of rafts loaded with agricultural products landed here or passed by on the river and adjacent canal. But Columbia, Wrightsville and Marietta declined in the twentieth century and have not always responded enthusiastically to efforts to revitalize the region. What happened Saturday night should provide a catalyst for success.

Water is the key. Successful river towns use their water in multifaceted ways. They create parks along it and on islands in it. They encourage entrepreneurs to build restaurants, ballparks and other entertaining places near it. And they encourage boaters and anglers to recreate in it.

Consider Harrisburg. Attractions at Riverfront Park and on City Island beckon visitors from a wide region. The riverboat *Pride of the Susquehanna* cruises regularly. The Harrisburg Symphony plays concerts on a river barge. Holiday festivals and fireworks are staged by the river. Several blocks of restaurants and nightclubs flourish on Second Street, as close as they can be to the water.

Consider York. Codorus Creek in York is hardly the Susquehanna at Harrisburg, but thanks to a bicycle trail and a relatively new cluster of restaurants and bars, that city also boasts an attractive entertainment center along and near the water.

Lancaster City has nothing similar. Lancaster County's commissioners wasted the only opportunity to use the Conestoga River as a community revitalization resource when they covered the crucial part of the Sunnyside Peninsula with a palatial prison for bad boys.

Columbia and Wrightsville may never be able to revitalize their waterfront to the extent Harrisburg has; but they can do much more than they have so far.

They are beginning. Columbia is improving its riverfront park and plans a seven-acre linear greenway along the Susquehanna. Wrightsville wants to restore old limekilns along the river. Rivertownes is promoting restoration of remnants of the riverside iron furnaces between Marietta and Columbia.

Now the towns need to focus on the river itself. Get people canoeing and kayaking on a new river trail down the Susquehanna. Stage a lively concert from a barge. Sponsor small boat tours and safe-boating education amid riffles between Marietta and Columbia, Accomac and Wrightsville.

Rivertownes and all of these towns can build on the spectacular success of June 28 by promoting the river as well as the riverfront. Water is for fishing and powerboating, yes; but it's also for playing around in gas-, oil- and noise-free kayaks and canoes, enjoying the scenery from Chickies Rock to Turkey Hill at a more leisurely pace.

When water places become people places, all the rest follows on shore: restaurants and nightclubs and other entertainment. Our old river towns could revitalize themselves by making the Susquehanna and its shores more inviting and entertaining. These towns need to project some of the spirit of last Saturday night every Saturday night.

TOO CLOSE: PRESERVATION, PROGRESS BARELY COEXIST

First published February 2, 2007

"Expect more, pay less." That's the motto of the Target Corporation, which opened its first Lancaster County store in 2005 along the Route 30 East tourist strip in East Lampeter Township.

"Where today touches history." That's the motto of the Amish Farm and House, an educational complex that launched Lancaster County's tourist industry when it opened half a century ago.

Contrasting mottoes and high-contrast goals.

So when New York developer Tim Harrison purchased the twenty-five-acre Amish Farm and House property, announcing that he would build a Target store there, many observers thought history must yield to commercialism. But that didn't happen—at least not entirely.

Harrison's completed development, Covered Bridge Marketplace, includes not only the 123,000-square-foot Target store and smaller shops but also the Amish Farm and House and the covered bridge of the old Willows Restaurant. The historical complex has been compressed into only fifteen of the twenty-five acres. But it's still explaining the Amish to tourists. And it's still a working farm: two lambs were born there this winter.

"The developer could have expanded the shopping center here, but he didn't," noted Mark Andrews, manager of the Amish Farm and House and the rest of Harrison's development. "You rarely see a commercial developer from Staten Island who cares about community and historical preservation," he added.

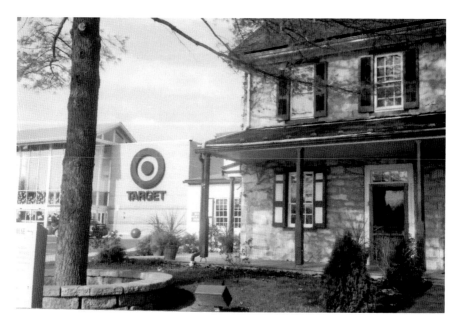

Customers shop at the Target store just steps away from the 1805 farmhouse of the Amish Farm and House in East Lampeter Township. *Photo by Jack Brubaker.*

While commending Harrison for preserving much of the farm, Andrews noted that the historical/commercial juxtaposition clearly illustrates what is happening in Lancaster County. The Amish Farm and House formerly had its own approach road leading from Route 30. The 1805 limestone farmhouse and 1803 bank barn stood well apart from more modern attractions along the strip. But now visitors reach the farm by way of the shopping center entrance. They park in the shopping center parking lot. They can only imagine what the house looked like before the Target store was built right up against it.

"This farm is a microcosm of what's happening in Lancaster County," said Eric Conner, the Amish Farm and House's marketing director.

"It's what the Amish have had to deal with for decades," said Andrews.

"Here's history just a few yards away from where you shop," added Conner. Here's a little of that history.

William Penn originally granted this land to John Evans, one of Pennsylvania's colonial governors. A distant Evans descendant built the farmhouse and barn, which eventually were taken over by a Mennonite family and then, briefly, by Amish. Adolph Neuber purchased the farm in 1955, adding it to adjacent land on which his family ran the Willows

Restaurant. Neuber turned the Amish Farm and House into the county's first tourist attraction. Today, staff members offer tours of the house and barn. They also take visitors through a new replica of an Amish schoolhouse. It has been especially popular since the shootings of ten Amish girls in the West Nickel Mines School. None of this would have continued if Harrison had decided to bulldoze the entire property.

In a preface to a brief history of the Amish Farm and House, Conner explains what has occurred in the township over the last few years. "Housing developments and shopping areas have inundated the once-untouched countryside," he writes. "'Outlet County' has replaced 'Amish County' in the vocabulary to describe the area." Conner advocates regulating or capping development so that other historical features will not be "lost among the commercial zones."

Most developers can't be expected to preserve anything.

But East Lampeter Township's supervisors should be prepared for the possibility. They should decide now that Target and the Amish Farm and House are too close for comfort. They should vow to do more in the future to set apart what was here first.

ABOUT THE AUTHOR

J ack Brubaker and his wife, Christine, live in Manor Township, Lancaster County. For more than three decades, he has written "The Scribbler" column for Lancaster Newspapers. He also is an investigative reporter and author of *Down the Susquehanna to the Chesapeake.*

Photo by Rick Hertzler.

Visit us at
www.historypress.net